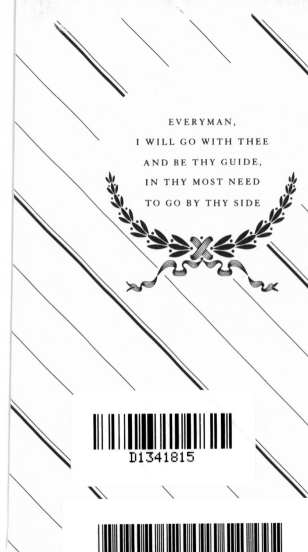

EVERYMAN,
I WILL GO WITH THEE
AND BE THY GUIDE,
IN THY MOST NEED
TO GO BY THY SIDE

EVERYMAN'S LIBRARY
POCKET POETS

ART AND ARTISTS

POEMS

••••••••••••••••••

EDITED BY
EMILY FRAGOS

EVERYMAN'S LIBRARY
POCKET POETS

Alfred A. Knopf New York London Toronto

THIS IS A BORZOI BOOK
PUBLISHED BY ALFRED A. KNOPF

This selection by Emily Fragos first published in
Everyman's Library, 2012
Copyright © 2012 by Everyman's Library

US website: www.randomhouse.com/everymans

ISBN 978-0-307-95938-6 (US)
978-1-84159-793-5 (UK)

A CIP catalogue record for this book is available from the British Library

Library of Congress Cataloging-in-Publication Data
Art and artists: poems / edited by Emily Fragos.
p. cm.—(Everyman's Library pocket poets)
ISBN 978-0-307-95938-6 (alk. paper)
1. Art—Poetry. 2. Artists—Poetry. 3. Poetry—Translations into
English. I. Fragos, Emily.
PN6110.A77A78 2012 2012000664
808.81'9357—dc23

Typography by Peter B. Willberg
Typeset in the UK by AccComputing, North Barrow, Somerset
Printed and bound in Germany by GGP Media GmbH, Pössneck

CONTENTS

PHOTOGRAPHY

OUTSIDER ART

FOREWORD

When a poet responds with his or her own art to a
work of visual art – applying speech to what is silent –
the resulting poem is termed ekphrastic, from the Greek
ek ("out of") and *phrasis* ("speech" or "expression").
Ekphrasis is sometimes translated simply as "descrip-
tion," and although description can certainly enter into
the picture, ekphrastic poems usually aim for far more.
A work of art can be a powerful inspiration and provo-
cation for a poet's deepest thoughts, feelings, inter-
pretations, meditations. Why am I drawn to this, the
poet asks, moved to tears by it, confused by it, made
more alive by it?

These responses can take many forms. In two of the
most famous ekphrastic poems in the English language,
John Keats and W. H. Auden use works of art as a
springboard for meditations on mortality and suffering.
Rainer Maria Rilke questions his very existence while
observing a sculpture of the god Apollo. William Carlos
Williams celebrates the robust, uncomplicated joy of a
peasants' dance in a Breughel painting. Czeslaw Milosz
invents a story for an Edward Hopper painting whose
stopped stillness invites so many questions. Theocritus
evokes the hard-working fisherman on an ancient ivy-
wood cup so vividly that one imagines him still at sea,
straining at his nets, the cords of his neck still bulging

with effort. Tomas Tranströmer wonders what is happening on the *other* side of Vermeer's painted tavern wall. As in the best ekphrastic poems, his imagination pushes through the wall to the unseen, the unpainted, and then it pushes out and down deeper, through the walls within us, those psychic boundaries that can be painful to cross.

In addition to painting, sculpture, photography, and architecture, the many related forms of visual artistry merit their own chapter. Here are poems that honor works as varied as stained glass, boxed assemblage, collage, engravings, tapestries, glass art, needlework, woodblock prints, calligraphy, silk scrolls, sculpted masks from Africa and the Orient, Hindu illumination, a Navajo blanket, carousel horses, a rock garden, draping, a book's frontispiece, illustrations, antiques, and a ship's figurehead.

So-called "Outsider" art is represented here as well. Also called *Art Brut* or Raw Art, these are the productions of self-taught artists, often working in solitude or secrecy, without knowledge of or interest in the art establishment or art history. Judith Scott, born deaf and with Down syndrome, created profoundly moving and mysterious fiber art out of found objects. Henry Darger, a reclusive janitor, amassed thousands of pages of a novel with illustrations of an elaborate fantasy realm. William Edmondson, an illiterate African-American,

claimed to have received a command from God to start sculpting his gracious and eloquent limestone figures. The deaf James Castle used saliva and soot to depict the hardscrabble life on his family's farm, eschewing a brush for a wooden stick, a canvas for a brown paper bag. Martín Ramírez, institutionalized as a schizophrenic, created large-scale collages and drawings depicting the prancing horses and proud caballeros of his native Mexico. The powerful and original visions of these "outsiders" have also inspired the homage of poets.

A few artists have been poet and painter both, bringing the two worlds of expression together, writing poems to accompany their paintings and drawings. William Blake, Dante Gabriel Rossetti, J. M. W. Turner and Michelangelo appear here as forerunners of those modern artists who use language in their multimedia works, erasing the walls between the arts.

In his famous phrase, *ut pictura poesis*, Horace linked poetry and painting as sister arts. I hope that these visions in verse prompt you to look ever more closely at all the forms of art that surround us, inside and outside of museums and galleries. As Richmond Lattimore noted in a poem about Thomas Eakins, "What you have done/made us see what we saw." Poetry has always helped us to see more fully, and perhaps never more so than in fruitful collision with the many splendors of the world of art.

ODE TO THE ARTIST

OLD MASTERS

The Old Masters
did without names

their signatures were
the white fingers of the Madonna

or the pink towers
di città sul mare

also scenes from the life
della Beata Umiltà

they dissolved
in *sogno*
miracolo
crocifissione

they found shelter
under angels' eyelids
behind hillocks of cloud
in the thick grass of paradise

drowned completely
in golden firmaments
without a cry of terror
or clamor for memory

their paintings' surfaces
are smooth as a mirror

they are not mirrors for us
but mirrors for the chosen

 I invoke you Old Masters
 in hard moments of doubt

 let pride's serpent scales
 fall from me by your aid

 let me remain unmoved
 by temptations of fame

 I invoke you Old Masters

 Painter of the Rain of Manna
 Painter of the Embroidered Trees
 Painter of the Visitation
 Painter of the Sacred Blood

ZBIGNIEW HERBERT (1924–2000)
TRANS. ALISSA VALLES

VERMEER

No sheltered world ... on the other side of the wall
 the noise begins
the tavern begins
with laughter and bickering, rows of teeth, tears,
 the din of bells
and the mentally disordered brother-in-law, the bearer
 of death that everyone must tremble for.

The great explosion and the delayed tramp of rescuers
the boats that strut at anchor, the money that creeps
 into the pocket of the wrong person
demands piled on demands
Cusps of gaping red flowers that sweat premonitions
 of war.

Away from there and straight through the wall
 into the bright studio
into the second that goes on living for hundreds
 of years.
Paintings titled *The Music Lesson*
or *Woman in Blue Reading a Letter* –
she's in her eighth month, two hearts kicking
 inside her.
On the wall behind her hangs a wrinkled map of
 Terra Incognita.

Breathes calmly ... An unknown blue material is nailed
 to the chair.
The gold upholstery tacks flew in with unheard-of speed
and stopped abruptly
as if they had never been anything but stillness.

The ears ring with either depth or height.
It's the pressure from the other side of the wall
that leaves every fact suspended
and holds the brush steady.

It hurts to go through walls, it makes you sick
but it's necessary.
The world is one. But walls ...
And the wall is part of yourself –
Whether you know it or not it's the same for everyone,
everyone except little children. No walls for them.

The clear sky has set itself on a slant against the wall.
It's like a prayer to emptiness.
And the emptiness turns its face to us
and whispers,
"I am not empty, I am open."

MUSÉE DES BEAUX ARTS

About suffering they were never wrong,
The Old Masters: how well they understood
Its human position; how it takes place
While someone else is eating or opening a window
 or just walking dully along;
How, when the aged are reverently, passionately
 waiting
For the miraculous birth, there always must be
Children who did not specially want it to happen,
 skating
On a pond at the edge of the wood:
They never forgot
That even the dreadful martyrdom must run
 its course
Anyhow in a corner, some untidy spot
Where the dogs go on with their doggy life and
 the torturer's horse
Scratches its innocent behind on a tree.

In Brueghel's *Icarus*, for instance: how everything
 turns away
Quite leisurely from the disaster; the ploughman may
Have heard the splash, the forsaken cry,
But for him it was not an important failure;
 the sun shone

As it had to on the white legs disappearing into
 the green
Water; and the expensive delicate ship that must
 have seen
Something amazing, a boy falling out of the sky,
Had somewhere to get to and sailed calmly on.

ODE ON A GRECIAN URN

Thou still unravished bride of quietness,
 Thou foster-child of silence and slow time,
Sylvan historian, who canst thus express
 A flowery tale more sweetly than our rhyme:
What leaf-fringed legend haunts about thy shape
 Of deities or mortals, or of both,
 In Tempe or the dales of Arcady?
 What men or gods are these? What maidens loath?
What mad pursuit? What struggle to escape?
 What pipes and timbrels? What wild ecstasy?

Heard melodies are sweet, but those unheard
 Are sweeter; therefore, ye soft pipes, play on;
Not to the sensual ear, but, more endeared,
 Pipe to the spirit ditties of no tone:
Fair youth, beneath the trees, thou canst not leave
 Thy song, nor ever can those trees be bare;
 Bold Lover, never, never canst thou kiss,
Though winning near the goal – yet, do not grieve;
 She cannot fade, though thou hast not thy bliss,
 Forever wilt thou love, and she be fair!

Ah, happy, happy boughs! that cannot shed
 Your leaves, nor ever bid the Spring adieu;
And, happy melodist, unwearièd,
 Forever piping songs forever new;

More happy love! more happy, happy love!
 Forever warm and still to be enjoyed,
 Forever panting, and forever young;
All breathing human passion far above,
 That leaves a heart high-sorrowful and cloyed,
 A burning forehead, and a parching tongue.

Who are these coming to the sacrifice?
 To what green altar, O mysterious priest,
Lead'st thou that heifer lowing at the skies,
 And all her silken flanks with garlands dressed?
What little town by river or sea shore,
 Or mountain-built with peaceful citadel,
 Is emptied of this folk, this pious morn?
And, little town, thy streets for evermore
 Will silent be; and not a soul to tell
 Why thou art desolate, can e'er return.

O Attic shape! Fair attitude! with brede
 Of marble men and maidens overwrought,
With forest branches and the trodden weed;
 Thou, silent form, dost tease us out of thought
As doth eternity: Cold Pastoral!
 When old age shall this generation waste,
 Thou shalt remain, in midst of other woe
 Than ours, a friend to man, to whom thou say'st,
"Beauty is truth, truth beauty, – that is all
 Ye know on earth, and all ye need to know."

From SLOW SONG FOR MARK ROTHKO

To breathe and stretch one's arms again
to breathe through the mouth to breathe to
breathe through the mouth to utter in
the most quiet way not to whisper not to whisper
to breathe through the mouth in the most quiet way to
breathe to sing to breathe to sing to breathe
to sing the most quiet way.

To sing to light the most quiet light in darkness
radiantia radiantia
singing light in darkness.

To sing as the host sings in his house.

To breathe through the mouth to breathe through the
mouth to breathe to sing to
sing in the most quiet way to
sing *the seeds in the earth breathe forth*
not to whisper *the seeds* not to whisper *in the earth*
to sing *the seeds in the earth* the most quiet way to
sing *the seeds in the earth breathe forth.*

To sing to light the most quiet light in darkness
radiant light of *seeds in the earth*
singing light in the darkness.

To sing as the host sings in his house.

To breathe through the mouth to breathe to sing
in the most quiet way not to
whisper *the seeds in the earth breathe forth*
to sing totality of *the seeds* not to eat to
sing *the seeds in the earth* to
be at ease to sing totality totality
to sing to be at ease.

To sing to light the most quiet light in darkness
be at ease with radiant *seeds*
with singing light in darkness.

To sing as the host sings in his house.

REMBRANDT

Art if human
is born out of pity
out of affinity with
the terror of the mortal
For this reason the greatest was the miller's son
Rembrandt
whose bodies are made of darkness and clay
heavy like the earth rarely shown bared
full of mysteries
his crowds – piles of funerary rags
his plants – out of a graveyard tin
the sky like the slit carcass of a steer
magnificent old men with brown hands
carnal women
half way on the return to non-being
He pitied the living
with the wisdom of his hand
knew that he was great
and with his peasant face
sealed the truth
while his Christ stood on the threshold of a ray of light
just before taking a step into human helplessness
Like every artist Christ is
sorrowful and lonely

ANNA KAMIENSKA (1920–86) 31
TRANS. GRAZYNA DRABIK AND DAVID CURZON

A GLANCE AT TURNER

His last words, "The Sun is God."
He found truth in color,
the Book of Revelation useful.
He cried out against the four angels
to whom it was given to hurt the earth and sea.
He followed a guiding star, a flight to Egypt,
a donkey burdened with the Word
and the Christian nation.
He gave a damn,
more than the sun, moon or darkness cared.
With a palette knife and thumb prints,
he answered the question,
"If God is the sun, what is the sunset?"
– proof the most pious death is by a kiss?
On his palette, primary colors,
something like never-before words,
his dead father, his mother in a madhouse.
He picked cherries with Claude and Poussin,
knew Rembrandt sometimes painted with his
 own feces,
that beauty may stink to heaven.
His own suffering never washed out of his brushes,
his Last Judgment, an angel with a sword, standing
 in the sun.
He did not know Blake's Last Judgment,

almost black from working and reworking.
Blake saw God sitting at the window,
Turner tried to pour sorrow out the window.
God breaketh not all men's hearts alike.
In the distant sky, beyond the stars there is
no Venice, no Titian, the Sun of Death shines.

A BOX OF PASTELS

I once held on my knees a simple wooden box
in which a rainbow lay dusty and broken.
It was a set of pastels that had years before
belonged to the painter Mary Cassatt,
and all of the colors she'd used in her work
lay open before me. Those hues she'd most used,
the peaches and pinks, were worn down to stubs,
while the cool colors – violet, ultramarine –
had been set, scarcely touched, to one side.
She'd had little patience with darkness, and her heart
held only a measure of shadow. I touched
the warm dust of those colors, her tools,
and left there with light on the tips of my fingers.

GIOTTO

O Lord, praise be
 to Brother Paintbrush. In Thy divine
 face of dew he has moistened himself, & dipped
 into Thy blood has come to shine.

O Lord, praise be
 to Brother Wall, open to me,
 to fresh lime, able to beat
 cold, water, air, heat –
 Sister Lime, with her pure white
 everlasting dream of life.

O Lord, praise be
 to the pencil, to the pen who drafts Brother Design.
 Praise be to the outline
 manifesting itself out of mist,
 praise be to Sister Light who clarifies it.

O Lord, praise be
 to the human form,
 ardent analogue of her vaster
 Sister Architecture.

O Lord, praise be
 to Brother Color, to his rainbow:
 to green, to white, to red & yellow,
 to black & gold & rose,
 to fraternal violet, and
 to the one whose bright language paints Thy praise
 when, looking up, I raise
 my hand to gather in the humble birds,
 and see/hear the lauding words
 of blue, of good Brother Indigo.

O Lord, praise be
 to solemn & deliberate movement,
 to the rigid landscape & hieratic sea. Praise be
 to the angel: a sail who has no need of Brother Wind,
 to a symmetry not tiresome to behold,
 to the rectilinear psalm of the robe.

O Lord, praisèd be
 what Thou hast done for me.
 In this dark age Thou hast made me sweet & gentle,
 and clothed me in a garment like no other:
 the bright habit of Painting's eldest brother.

RAFAEL ALBERTI (1902–99)
 TRANS. CAROLYN L. TIPTON

WYETH'S MILK CANS

Beyond them, hill and field
Harden, and summer's easy
Wheel-ruts lie congealed.

What if these two bells tolled?
They'd make the bark-splintering
Music of pure cold.

From THE HORIZONTAL LINE
(Homage to Agnes Martin)

It was like a white sail in the early morning

———

It was like a tremulous wind calming itself
After a night on the thunderous sea

———

The exhausted lightning lay down on its side
And slept on a bed of cumulous sheets

———

She came out of the mountains
And surrendered to the expansiveness of a plain

———

She underlined a text in *Isaiah*:
Make level in the desert
A highway for our God
Every valley shall be exalted
And every mountain and hill shall be made low

———

The mountain grew tired of striving upward
And longed to flatten its ragged peaks

———

The nostalgia of a cathedral for the open plain

———

The nostalgia of a soprano for plainsong

———

From BEAUTY IS CONVULSIVE:
THE PASSION OF FRIDA KAHLO

there, there ... touch me there
and you add paint tenderly sweetly
touch me –
and she puts a little paint – *there*
something blooms
a ripe fruit
her face
the dark corridors of sensibility
A skull with flowers
look
She smiles.

dalliance grief in the afternoon, love

navy blue: distance. Also tenderness can be of this blue.

from the near and far

Blood in the corner now saturating the page
Accident: the landscape is day and night.
obscene

obscene
and the little deer

In Aztec mythology and iconography, the image of
 the deer
stands for the right foot, and it was this part of Frida's
 body that
was now full of pain.

URGENT TELEGRAM TO
JEAN-MICHEL BASQUIAT

HAVENT HEARD FROM YOU IN AGES
STOP LOVE YOUR LATEST SHOW STOP
THIS NO PHONE STUFF IS FOR BIRDS
LIKE YOU STOP ONCE SHOUTED UP
FROM STREET ONLY

RAIN AND YOUR ASSISTANT ANSWERED
STOP DO YOU STILL SLEEP LATE STOP
DOES YOUR PAINT STILL COVER DOORS
STOP FOUND A SAMO TAG COPYRIGHT
HIGH

ABOVE A STAIR STOP NOT SURE HOW
YOU REACHED STOP YOU ALWAYS WERE
A CLIMBER STOP COME DOWN SOME
DAY AND SEE US AGAIN END

KEVIN YOUNG (1970–) 41

From VELÁZQUEZ

A chisel, at your touch,
would've turned into a brush,
in your hands, always
a brush/the rush of wings.

*

"From vaporous depths
I rise and mass, take
floating human form."

*

The drunk says,
 "I have the noble face
of prince & drunk –
of a drunken prince, or of a sot
who could've been a king."

*

And the fool,
 "I am portrayed
as if I were the King or the Count-Duke:
Don Felipe Buffoon de Olivares!"

*

Who's the nobler hunter? The prince who shifts
his gun between gloved fingers, or the dog
who looks out, quiet, at his feet?

*

The blue-blooded dogs of Velázquez.

*

A wolfhound says,
 "My portrait is so fine
I am convinced I could've run the realm."

*

And a whippet,
 "Hound prince you may call me . . .
His Majesty Felipe Whippet IV."

*

But the horses, too,
ought to be crowned!

*

"I make the children ring out like blond
bells: peals of color."

RAFAEL ALBERTI (1902–99)
TRANS. CAROLYN L. TIPTON

THE SHIELD OF ACHILLES
From *The Iliad*, Book XVIII

Thetis goes to the palace of Vulcan to obtain new arms for her son.

Thus having said, the father of the fires
To the black labours of his forge retires.
Soon as he bade them blow, the bellows turn'd
Their iron mouths; and where the furnace burn'd,
Resounding breathed: at once the blast expires,
And twenty forges catch at once the fires;
Just as the god directs, now loud, now low,
They raise a tempest, or they gently blow;
In hissing flames huge silver bars are roll'd,
And stubborn brass, and tin, and solid gold;
Before, deep fix'd, the eternal anvils stand;
The ponderous hammer loads his better hand,
His left with tongs turns the vex'd metal round,
And thick, strong strokes, the doubling vaults
 rebound.

Then first he form'd the immense and solid shield;
Rich various artifice emblazed the field;
Its utmost verge a threefold circle bound;
A silver chain suspends the massy round;
Five ample plates the broad expanse compose,

And godlike labours on the surface rose.
There shone the image of the master-mind:
There earth, there heaven, there ocean he design'd;
The unwearied sun, the moon completely round;
The starry lights that heaven's high convex crown'd;
The Pleiads, Hyads, with the northern team;
And great Orion's more refulgent beam;
To which, around the axle of the sky,
The Bear, revolving, points his golden eye,
Still shines exalted on the ethereal plain,
Nor bathes his blazing forehead in the main.

Two cities radiant on the shield appear,
The image one of peace, and one of war.
Here sacred pomp and genial feast delight,
And solemn dance, and hymeneal rite;
Along the street the new-made brides are led,
With torches flaming, to the nuptial bed:
The youthful dancers in a circle bound
To the soft flute, and cithern's silver sound:
Through the fair streets the matrons in a row
Stand in their porches, and enjoy the show.

HOMER (*fl.* 850 B.C.) 45
TRANS. ALEXANDER POPE

TO CARAVAGGIO

The Hispanic boy beside me – nude, only mildly
 muscled,
a slight tracing of hair above the heart-searing curve
 of his upper lip –
is next in line for a massage, so he lies down on the
 pool table,

covered tonight with a sheet of black plywood,
 a black tarp,
and long rows of paper towels. He's so finely white
 he's nearly blue,
and as the masseur begins – first a light coating of
 oil for traction,

then the rub in earnest; down the back, working
 the neck
and shoulders, the long thighs, turning him over,
 polishing
the long abdomen, raising toward the ceiling lamp

the firm and slender chest. And now he seems a cadaver,
laid out, or a boy posing as a corpse, inert, eyes at ease,
mouth entirely tranquil. All in a ring around the table,

young men and grizzled elders watching,
and two splendid witnesses like visiting kings
without their fine robes, their perfect skin shading
 into the darkness.

Then the masseur lifts the arms above the head,
 to stretch
the lats and shoulders, and suddenly the boy's the
 corpus of our Lord
still nailed to his cross, shockingly real, the dark
 of the room

composing itself, in lustrous blacks, around the
 suspended body.

GAUGUIN
From *Midsummer*

On the quays of Papeete, the dawdling white-ducked
 colonists
drinking with whores whose skin is the copper of
 pennies
pretend, watching the wild skins of the light and shade,
that a straight vermouth re-creates the metropolis,
but the sun has scorched those memories from
 my head –
Cézanne bricking in color, each brick no bigger than
 a square inch,
the pointillists' dots like a million irises.
I saw in my own cheekbones the mule's head of a Breton,
the placid, implacable strategy of the Mongol,
the moustache like the downturned horns of a helmet;
the chain of my blood pulled me to darker nations,
though I looked like any other sallow, crumpled colon
stepping up to the pier that day from the customs
 launch.
I am Watteau's wild oats, his illegitimate heir.
Get off your arses, you clerks, and find your fate,
the devil's prayer book is the hymn of patience,
grumbling in the fog. Pack, leave! I left too late.

WOLF'S TREES
For Wolf Kahn

If trees fall in a wood and no one hears them,
Do they exist except as a page of lines
That words of rapture or grief are written on?
They are lines too while alive, pointing away
From the primer of damped air and leafmold
That underlie, or would if certain of them
Were not melon or maize, solferino or smoke,
Colors into which a sunset will collapse
On a high branch of broken promises.
Or they nail the late summer's shingles of noon
Back onto the horizon's overlap, reflecting
An emptiness visible on leaves that come and go.

How does a life flash before one's eyes
At the end? How is there time for so much time?
You pick up the book and hold it, knowing
Long since the failed romance, the strained
Marriage, the messenger, the mistake,
Knowing it all at once, as if looking through
A lighted dormer on the dark crest of a barn.
You know who is inside, and who has always been
At the other edge of the wood. She is waiting
For no one in particular. It could be you.
If you can discover which tree she has become,
You will know whether it has all been true.

J. D. MCCLATCHY (1945–) 49

"IN GOYA'S GREATEST SCENES WE SEEM TO SEE"

In Goya's greatest scenes we seem to see
 the people of the world
 exactly at the moment when
 they first attained the title of
 "suffering humanity"
 They writhe upon the page
 in a veritable rage
 of adversity
 Heaped up
 groaning with babies and bayonets
 under cement skies
 in an abstract landscape of blasted trees
 bent statues bats wings and beaks

 slippery gibbets
 cadavers and carnivorous cocks
 and all the final hollering monsters
 of the
 "imagination of disaster"
 they are so bloody real
 it is as if they really still existed
 And they do

 Only the landscape is changed

They still are ranged along the roads
 plagued by legionnaires
 false windmills and demented roosters

 They are the same people
 only further from home
 on freeways fifty lanes wide
 on a concrete continent
 spaced with bland billboards
 illustrating imbecile illusions of happiness
 The scene shows fewer tumbrils
 but more maimed citizens
 in painted cars
 and they have strange license plates
 and engines
 that devour America

THE GREAT WAVE: HOKUSAI

It is because the sea is blue,
Because Fuji is blue, because the bent blue
Men have white faces, like the snow
On Fuji, like the crest of the wave in the sky the color
 of their
Boats. It is because the air
Is full of writing, because the wave is still: that nothing
Will harm these frail strangers,
That high over Fuji in an earthcolored sky the fingers
Will not fall; and the blue men
Lean on the sea like snow, and the wave like a
 mountain leans
Against the sky.

In the painter's sea
All fishermen are safe. All anger bends under his unity.
But the innocent bystander, he merely
'Walks round a corner, thinking of nothing': hidden
Behind a screen we hear his cry.
He stands half in and half out of the world; he is the men,
But he cannot see below Fuji
The shore the color of sky; he is the wave, he stretches
His claws against strangers. He is
Not safe, not even from himself. His world is flat.
He fishes a sea full of serpents, he rides his boat
Blindly from wave to wave toward Ararat.

COROT

The music of music is stillness, you birds,
Cease a moment in reverence
And listen, oh Everything, listen, for words
Foil the sense.

The trees rise taller and taller, lifted
On the subtle rush of the cool grey flame
That issuing out of the moon has sifted
The spirit from each leaf's frame.

For the trailing, leisurely rapture of life
Drifts dimly forward easily hidden
By noise of small birds singing: fife
Of noisy birds, be you chidden.

The grey phosphorescent, pellucid advance
Of the luminous Purpose of God shines out
Where the lofty trees athwart stream perchance
Shake flakes of its meaning about.

The subtle, steady rush of the whole
Grey foam-fringe of advancing God
As he silently sweeps to his somewhere, his goal,
Is heard in the grass of the sod.

Is heard in the windless whisper of leaves,
In the far-off labour of men in the field
In the down-ward drooping flimsy sheaves
Of cloud, the morn skies yield.

In the tapping haste of a fallen leaf
In the flapping of red-roof smoke, and the small
Footstepping tap of men beneath
These trees so huge and tall.

For what can all sharp-rimmed substance but catch
In a backward ripple God's progress reveal
For a moment his great direction, scratch
A spark beneath his wheel.

Since God sweeps onward dim and vast
Down every channelled vein of man
Or leaf, and his passing shadow is cast
On each face for us to scan.

Then listen, for silence is not lonely,
Imitate the magnificent trees
That speak no word of their rapture, but only
Breathe largely the Luminous breeze.

RENOIR
for Donald Davie

Under striped flutter of awnings, they have come
together this afternoon to glitter with
carafes and wine glasses, and the fluffy dog
perched on the table amid parings
of apples and peaches. They rehearse
a civilization here among
bright collaborations of sun. The two
gentlemen nearest us take their ease
bare-armed, in undershirts. At the next
table, brown jacket and bowler melt
into ingenious dapple and nonchalance,
and only the farthest gentlemen, vertical, sustain
in suits and top hats, a dark
decorum. And ladies, ladies –
bonnetted, buttoned at neck
and wrists, yet ripe
with sleep: their cheeks
and half-closed eyes give them away.
Flesh is fruit, whispers the brush, and sunlight
wine; all cloth
dissolves. And when these chroma
and characters have faded
into the single, sensual blur of an afternoon
lost, there will remain

ghostly vermilion, hieroglyphic lips,
awning stripes and anemones that once
so vulgarly blazed, now dimming to
the mystic map of sprawl, spatter, and glare:
not Jeanne, Marie-Thérèse, Alphonse, Auguste,
 but this –
this truest pattern, radiance revealed,
a constellation visible at dusk.

From ODE TO SALVADOR DALÍ

Oh Salvador Dalí, of the olive-colored voice!
I speak of what your person and your paintings tell me.
I do not praise your halting adolescent brush,
but I sing the steady aim of your arrows.

I sing your fair struggle of Catalan lights,
your love of what might be made clear.
I sing your astronomical and tender heart,
a never-wounded deck of French cards.

I sing your restless longing for the statue,
your fear of the feelings that await you in the street.
I sing the small sea siren who sings to you,
riding her bicycle of corals and conches.

But above all I sing a common thought
that joins us in the dark and golden hours.
The light that blinds our eyes is not art.
Rather it is love, friendship, crossed swords.

Not the picture you patiently trace,
but the breast of Theresa, she of sleepless skin,
the tight-wound curls of Mathilde the ungrateful,
our friendship, painted bright as a game board.

May fingerprints of blood on gold
streak the heart of eternal Catalunya.
May stars like falconless fists shine on you,
while your painting and your life break into flower.

Don't watch the water clock with its membraned
 wings
or the hard scythe of the allegory.
Always in the air, dress and undress your brush
before the sea peopled with sailors and with ships.

THE PAINTINGS

SAN SEPOLCRO

In this blue light
 I can take you there,
snow having made me
 a world of bone
seen through to. This
 is my house,

my section of Etruscan
 wall, my neighbor's
lemontrees, and, just below
 the lower church,
the airplane factory.
 A rooster

crows all day from mist
 outside the walls.
There's milk on the air,
 ice on the oily
lemonskins. How clean
 the mind is,

holy grave. It is this girl
 by Piero
della Francesca, unbuttoning
 her blue dress,
her mantle of weather,
 to go into

labor. Come, we can go in.
 It is before
the birth of god. No one
 has risen yet
to the museums, to the assembly
 line – bodies

and wings – to the open air
 market. This is
what the living do: go in.
 It's a long way.
And the dress keeps opening
 from eternity

to privacy, quickening.
 Inside, at the heart,
is tragedy, the present moment
 forever stillborn,
but going in, each breath
 is a button

coming undone, something terribly
 nimble-fingered
finding all of the stops.

THE DANCE

In Breughel's great picture, The Kermess,
the dancers go round, they go round and
around, the squeal and the blare and the
tweedle of bagpipes, a bugle and fiddles
tipping their bellies (round as the thick-
sided glasses whose wash they impound)
their hips and their bellies off balance
to turn them. Kicking and rolling about
the Fair Grounds, swinging their butts, those
shanks must be sound to bear up under such
rollicking measures, prance as they dance
in Breughel's great picture, The Kermess.

ON CARPACCIO'S PICTURE,
THE DREAM OF ST URSULA

Swept, clean, and still, across the polished floor
 From some unshuttered casement, hid from sight,
 The level sunshine slants, its greater light
Quenching the little lamp which pallid, poor,
Flickering, unreplenished, at the door
 Has striven against darkness the long night.
 Dawn fills the room, and penetrating, bright,
The silent sunbeams through the window pour.
 And she lies sleeping, ignorant of Fate,
 Enmeshed in listless dreams, her soul not yet
Ripened to bear the purport of this day.
 The morning breeze scarce stirs the coverlet,
 A shadow falls across the sunlight; wait!
A lark is singing as he flies away.

MUSÉE DES BEAUX ARTS REVISITED

As far as mental anguish goes,
the old painters were no fools.
They understood how the mind,
the freakiest dungeon in the castle,
can effortlessly imagine a crab with the face of a priest
or an end table complete with genitals.

And they knew that the truly monstrous
lies not so much in the wildly shocking,
a skeleton spinning a wheel of fire, say,
but in the small prosaic touch
added to a tableau of the hellish,
the detail at the heart of the horrid.

In Bosch's *The Temptation of St Anthony*,
for instance, how it is not so much
the boar-faced man in the pea-green dress
that frightens, but the white mandolin he carries,
not the hooded corpse in a basket,
but the way the basket is rigged to hang from a
 bare branch;

how, what must have driven St Anthony
to the mossy brink of despair
was not the big, angry-looking fish

in the central panel,
the one with the two mouse-like creatures
conferring on its tail,
but rather what the fish is wearing:

a kind of pale orange officer's cape
and, over that,
a metal body-helmet secured by silvery wires,
a sensible buckled chin strap,
and, yes, the ultimate test of faith –
the tiny sword that hangs from the thing,
that nightmare carp,
secure in its brown leather scabbard.

ON A PAINTING BY WANG
THE CLERK OF YEN LING

The slender bamboo is like a hermit.
The simple flower is like a maiden.
The sparrow tilts on the branch.
A gust of rain sprinkles the flowers.
He spreads his wings to fly
And shakes all the leaves.
The bees gathering honey
Are trapped in the nectar.
What a wonderful talent
That can create an entire Spring
With a brush and a sheet of paper.
If he would try poetry
I know he would be a master of words.

SU TUNG P'O (1036–1101)

TRANS. KENNETH REXROTH

THE CARD-PLAYERS
[On a seventeenth-century Dutch genre painting]

Jan van Hogspeuw staggers to the door
And pisses at the dark. Outside, the rain
Courses in cart-ruts down the deep mud lane.
Inside, Dirk Dogstoerd pours himself some more,
And holds a cinder to his clay with tongs,
Belching out smoke. Old Prijck snores with the gale,
His skull face firelit; someone behind drinks ale,
And opens mussels, and croaks scraps of songs
Towards the ham-hung rafters about love.
Dirk deals the cards. Wet century-wide trees
Clash in surrounding starlessness above
This lamplit cave, where Jan turns back and farts,
Gobs at the grate, and hits the queen of hearts.

Rain, wind and fire! The secret, bestial peace!

A FLOWER-PIECE BY FANTIN

Heart's ease or pansy, pleasure or thought,
Which would the picture give us of these?
Surely the heart that conceived it sought
Heart's ease.

Surely by glad and divine degrees
The heart impelling the hand that wrought
Wrought comfort here for a soul's disease.

Deep flowers, with lustre and darkness fraught,
From glass that gleams as the chill still seas
Lean and lend for a heart distraught
Heart's ease.

CY TWOMBLY'S *UNTITLED*
(SAY GOODBYE, CATULLUS,
TO THE SHORES OF ASIA MINOR)
The Twombly Gallery, Houston, Texas

A child could not have drawn this.
Maybe something more like 67 children.
(Each with his or her own favorite ice cream.)
 And not just
Ordinary children. All 67 would have five arms each.
And each arm would have three hands and each hand
Would hold three brushes and two pencils.

And, in his or her own way, each child would love and
 hate Catullus.
Love him so much that they would crawl the streets
 of Rome in search of him.
Hate him so much that they would crawl the streets
 of Rome in search of him.

335 arms to embrace him. 1005 hands to maul him.

Catullus, give back all the beautiful words.

O!
Edward Hopper (1882–1967)
A Hotel Room
THYSSEN COLLECTION, LUGANO

O what sadness unaware that it's sadness!
What despair that doesn't know it's despair!

A businesswoman, her unpacked suitcase on the floor,
sits on a bed half undressed, in red underwear, her hairdo
irreproachable; she has a piece of paper in her hand,
probably with numbers.

Who are you? Nobody will ask. She doesn't know either.

WATTEAU
From *Midsummer*
[On Jean-Antoine Watteau's *Embarkation for Cythera*]

The amber spray of trees feather-brushed with the dusk,
the ruined cavity of some spectral château, the groin
of a leering satyr eaten with ivy. In the distance,
 the grain
of some unreapable, alchemical harvest, the hollow at
the heart of all embarkations. Nothing stays green
in that prodigious urging towards twilight;
in all of his journeys the pilgrims are in fever
from the tremulous strokes of malaria's laureate.
So where is Cythera? It, too, is far and feverish,
it dilates on the horizon of his near-delirium, near
and then further, it can break like the spidery rigging
of his ribboned barquentines, it is as much nowhere
as these broad-leafed islands, it is the disease
of elephantine vegetation in Baudelaire,
the tropic bug in the Paris fog. For him, it is the mirror
of what is. Paradise is life repeated spectrally,
an empty chair echoing the emptiness.

THE DISQUIETING MUSES
From *Two de Chiricos*
[On Giorgio de Chirico]

Boredom sets in first, and then despair.
One tries to brush it off. It only grows.
Something about the silence of the square.

Something is wrong; something about the air,
Its color; about the light, the way it goes.
Something about the silence of the square.

The muses in their fluted evening wear,
Their faces blank, might lead one to suppose
Something about the silence of the square,

Something about the buildings standing there.
But no, they have no purpose but to pose.
Boredom sets in first, and then despair.

What happens after that, one doesn't care.
What brought one here – the desire to compose
Something about the silence of the square,

Or something else, of which one's not aware,
Life itself, perhaps – who really knows?
Boredom sets in first, and then despair...
Something about the silence of the square.

MARK STRAND (1934–) 73

GOYA'S "TWO OLD PEOPLE EATING SOUP"

My eyes
consumed the bowl
whole.
The red beans
rolled under my gums
and the carrots were blazing
with life, with *life*.

FOR AN ANNUNCIATION,
EARLY GERMAN

The lilies stand before her like a screen
 Through which, upon this warm and solemn day,
 God surely hears. For there she kneels to pray
Who wafts our prayers to God – Mary the Queen.
She was Faith's Present, parting what had been
 From what began with her, and is for aye.
 On either hand, God's twofold system lay:
With meek bowed face a Virgin prayed between.
So prays she, and the Dove flies in to her,
 And she has turned. At the low porch is one
 Who looks as though deep awe made him to smile.
Heavy with heat, the plants yield shadow there;
 The loud flies cross each other in the sun;
 And the aisled pillars meet the poplar-aisle.

DANTE GABRIEL ROSSETTI (1828–82)

EDGAR DEGAS: *THE MILLINERY SHOP*

Hats are innocent, bathed in the soft light
which smoothes the contours of objects.
A girl is working.
But where are brooks? Groves?
Where is the sensual laughter of nymphs?
The world is hungry and one day
will invade this tranquil room.
For the moment it contents itself
with ambassadors who announce:
I'm the ochre. I'm the sienna.
I'm the color of terror, like ash.
In me ships sink.
I'm the blue, I'm cold, I can be pitiless.
And I'm the color of dying, I'm patient.
I'm the purple (you don't see much of me),
for me triumphs, processions.
I'm the green, I'm tender,
I live in wells and in the leaves of birch trees.
The girl whose fingers are agile
cannot hear the voices, for she's mortal.
She thinks of the coming Sunday
and the rendezvous she has
with the butcher's son
who has coarse lips
and big hands
stained with blood.

ADAM ZAGAJEWSKI (1945–)
TRANS. CLARE CAVANAGH

MONET'S "WATERLILIES"
(*for Bill and Sonja*)

Today as the news from Selma and Saigon
poisons the air like fallout,
 I come again to see
the serene great picture that I love.

Here space and time exist in light
the eye like the eye of faith believes.
 The seen, the known
dissolve in iridescence, become
illusive flesh of light
 that was not, was, forever is.

O light beheld as through refracting tears.
Here is the aura of that world
 each of us has lost.
Here is the shadow of its joy.

ROBERT HAYDEN (1913–80) 77

THE LAST SUPPER
[On Leonardo da Vinci]

The heaven of the supper fell in love with the wall.
It filled it with cracks. It fills them with light.
It fell into the wall. It shines out there
in the form of thirteen heads.

And that's my night sky, before me,
and I'm the child standing under it,
my back getting cold, an ache in my eyes,
and the wall-battering heaven battering me.

At every blow of the battering ram
stars without eyes rain down,
new wounds in the last supper,
the unfinished mist on the wall.

OSIP MANDELSTAM (1891–1938)
TRANS. CLARENCE BROWN AND W. S. MERWIN

O!
Gustav Klimt (1862–1918)
Judith *(detail)*
ÖSTERREICHISCHE MUSEUM

O lips half opened, eyes half closed, the rosy nipple of
your unveiled nakedness, Judith!

And they, rushing forward in an attack with your image
preserved in their memories, torn apart by bursts of
artillery shells, falling down into pits, into putrefaction.

O massive gold of your brocade, of your necklace with
its rows of precious stones, Judith, for such a farewell!

CZESLAW MILOSZ (1911–2004)
TRANS. CZESLAW MILOSZ AND ROBERT HASS

BLUE POLES

Tonight, away begins to go
farther away, and the dream
what do we know of the dream
metallic leaps Jackson Pollock
silvery streams Jackson Pollock
I gaze across the sea

see in the distance your walk and you
pass the Pacific, distant and blue
phallus and Moloch pace my view
on into otherness

on into otherness?
are we in the world after or before
are we or are we not magnetic force
it is apparently me you inform:

genesis woman dream that begins
tonight to go farther away
tonight to reach farther away
metallic leaps Jackson Pollock
silvery streams Jackson Pollock
on across the blue sea

INGER CHRISTENSEN (1935–2009)
TRANS. SUSANNA NIED

THE EARLIEST ANGELS
[On Paul Klee's *Strange Glance*]

The earliest angels were swarthy, stooped,
hairy, with a flat forehead
and crested skulls,
arms down to the knees. In place of wings
just two parachutes of skin,
a kind of black flying squirrel
in the volcanic winds.

Totally trustworthy.
They performed astounding miracles.
Transubstantiations. Metamorphoses
of mud into mud fish.
A rocking horse,
inflated to heavenly size,
atomic fusion at room temperature,
holding up the mirror,
stirrings of consciousness,
creating the majesty of death.

They worked hard.
They tinkered with graves.
They swam in murky waters.
They huddled in oviducts.
They hid behind the door.

They waited.
 They waited in vain.

MIROSLAV HOLUB (1923–98) 81
TRANS. DAVID YOUNG AND DENNIS O'DRISCOLL

From SEURAT'S SUNDAY AFTERNOON
ALONG THE SEINE
To Meyer and Lillian Schapiro

What are they looking at? Is it the river?
The sunlight on the river, the summer, leisure,
Or the luxury and nothingness of consciousness?
A little girl skips, a ring-tailed monkey hops
Like a kangaroo, held by a lady's lead
(Does the husband tax the Congo for the monkey's
 keep?)
The hopping monkey cannot follow the poodle
 dashing ahead.

Everyone holds his heart within his hands:

A prayer, a pledge of grace or gratitude
A devout offering to the god of summer, Sunday and
 plenitude.

The Sunday people are looking at hope itself.

They are looking at hope itself, under the sun, free from
 the teething anxiety, the gnawing nervousness
Which wastes so many days and years of
 consciousness.

The one who beholds them, beholding the gold and
 green
Of summer's Sunday is himself unseen. This is because
 he is
Dedicated radiance, supreme concentration, fanatically
 threading
The beads, needles and eyes – at once! – of vividness
 and permanence.
He is a saint of Sunday in the open air, a fanatic
 disciplined
By passion, courage, passion, skill, compassion, love:
 the love of life and the love of light as one, under
 the sun, with the love of life.

Everywhere radiance glows like a garden in stillness
 blossoming.

DELMORE SCHWARTZ (1913–66)

ON DELACROIX'S "TASSO IN PRISON"

The poet in the dungeon – ragged, sick,
and trampling on a manuscript in shreds –
measures with a panic-stricken glare
the dizzying stairs that swallow up his soul.

Beguiled by ghostly laughter in the air
his reason falters, grasps at phantom straws;
Doubt besieges him and imbecile Fears
in hideous yet ever-changing shapes...

This genius confined in a filthy hole,
these shrieks and grimaces, the spectral swarm
gibbering spitefully behind his ear,

this dreamer whom the madhouse horror wakes –
here is your emblem, visionary soul,
smothered by Reality between four walls!

84 CHARLES BAUDELAIRE (1821–67)
TRANS. RICHARD HOWARD

FOR SPRING, BY SANDRO BOTTICELLI, IN THE ACCADEMIA OF FLORENCE

What masque of what old wind-withered New-Year
 Honours this Lady? Flora, wanton-eyed
 For birth, and with all flowrets prankt and pied:
Aurora, Zephyrus, with mutual cheer
Of clasp and kiss: the Graces circling near,
 'Neath bower-linked arch of white arms glorified:
 And with those feathered feet which hovering glide
O'er Spring's brief bloom, Hermes the harbinger.

Birth-bare, not death-bare yet, the young stems stand,
 This Lady's temple-columns: o'er her head
 Love wings his shaft. What mystery here is read
Of homage or of hope? But how command
 Dead Springs to answer? And how question here
 These mummers of that wind-withered New-Year?

DANTE GABRIEL ROSSETTI (1828–82) 85

ON THE GROUP OF THE THREE ANGELS
BEFORE THE TENT OF ABRAHAM,
BY RAFAELLE, IN THE VATICAN

Oh, now I feel as though another sense
From Heaven descending had informed my soul!
I feel the pleasurable, full control
Of Grace, harmonious, boundless, and intense.
In thee, celestial Group, embodied lives
The subtle mystery; that speaking gives
Itself resolv'd: the essence combin'd
Of Motion ceaseless, Unity complete.
Borne like a leaf by some soft eddying wind,
Mine eyes, impell'd as by enchantment sweet,
From part to part with circling motion rove,
Yet seem unconscious of the power to move;
From line to line through endless changes run,
O'er countless shapes yet seem to gaze on One.

From THE MAN WITH THE BLUE GUITAR
[On Pablo Picasso's *The Old Guitarist*]

I

The man bent over his guitar,
A shearsman of sorts. The day was green

They said, "You have a blue guitar,
You do not play things as they are."

The man replied, "Things as they are
Are changed upon the blue guitar."

And they said then, "But play, you must,
A tune beyond us, yet ourselves,

A tune upon the blue guitar
Of things exactly as they are."

II

I cannot bring a world quite round,
Although I patch it as I can.

I sing a hero's head, large eye
And bearded bronze, but not a man,

Although I patch him as I can
And reach through him almost to man.

If to serenade almost to man
Is to miss, by that, things as they are,

Say that it is the serenade
Of a man that plays a blue guitar.

III

Ah, but to play man number one,
To drive the dagger in his heart,

To lay his brain upon the board
And pick the acrid colors out,

To nail his thought across the door,
Its wings spread wide to rain and snow,

To strike his living hi and ho,
To tick it, tock it, turn it true,

To bang it from a savage blue,
Jangling the metal of the strings...

IV

So that's life, then: things as they are?
It picks its way on the blue guitar.

A million people on one string?
And all their manner in the thing.

And all their manner, right and wrong,
And all their manner, weak and strong?

The feelings crazily, craftily call,
Like a buzzing of flies in autumn air,

And that's life, then: things as they are,
This buzzing of the blue guitar.

WALLACE STEVENS (1879–1955)

WORMWOOD: THE PENITENTS
[On Georgia O'Keeffe's *Black Cross, New Mexico*]

I always thought she ought to have an angel.
There's one I saw a picture of, smooth white,
the wings like bolts of silk, breasts like a girl's –
like hers – eyebrows, all of it. For years
I put away a little every year,
but her family was shamed by the bare grave,
and hadn't they blamed me for everything,
so now she has a cross. Crude, rigid, nothing
human in it, flat dead tree on the hill,
it's what you see for miles, it's all I see.
Symbol of hope, the priest said, clearing his throat,
and the rain came down and washed the formal flowers.
I guess he thinks that dusk is just like dawn.
I guess he had forgot about the nails.

ON A WINDY WASH DAY MORN
[On Grandma Moses's *Wash Day*]

Soaked and scrubbed in a round tin tub
with homemade soap
up and down the ribs of a wooden washboard
by hands rubbed red & raw
on a windy wash day morn.

Stiffened with starch, squeezed
and wrung to a twisted laundry rope
then hung on lines to flap
back and forth and snap dry
on a windy wash day morn.

Laid on the lawn like paper cutouts
clean shirts and sheets, towels and skirts
smelling of sun and clouds and wind
wait to be ironed and worn and dirtied
again for another wash day morn.

BRENDA SEABROOKE (1941–)

MAX SCHMITT IN A SINGLE SCULL

How shall the river learn
its winter look, steel and brown, how shall we
upon our moving mirror here discern
the way light falls on bridge and bare tree
except as in the painting? Cold fires burn

autumn into winter. Here still
the pencilled sculls dip, precise arms beat
the water-circles of their progress. Skill
arrowheads elegance. City Line to 30th Street
is forever, Eakins, your Schuylkill

and ours. What you have done
made us see what we saw. Thus our eyes
after your image catch the steel and brown
of rowers on the water, improvise
by you our colors in the winter sun.

TOULOUSE-LAUTREC AT THE
MOULIN ROUGE

"Cognac – more cognac for Monsieur Lautrec –
More cognac for the little gentleman,
Monster or clown of the Moulin – quick –
Another glass!"
 The Can Can
Chorus with their jet net stockings
And their red heads rocking
Have brought their patrons flocking to the floor.
Pince-nez, glancing down from legs advancing
To five fingers dancing
Over a menu-card, scorn and adore
Prostitutes and skinny flirts
Who crossing arms and tossing skirts
High-kick – a quick
Eye captures all before they fall –
Quick lines, thick lines
Trace the huge ache under rouge.

"Cognac – more cognac!" Only the slop
Of a charwoman pushing her bucket and mop,
And the rattle of chairs on a table top.
The glass can fall no further. Time to stop
The charcoal's passionate waltzing with the hand.
Time to take up the hat, drag out the sticks,

And very slowly, like a hurt crab, stand:
With one wry bow to the vanished band,
Launch out with short steps harder than high kicks
Along the unspeakable inches of the street.
His flesh was his misfortune: but the feet
Of those whose flesh was all their fortune beat
Softly as the grey rain falling
Through his brain recalling
Marie, Annette, Jean-Claude and Marguerite.

"DON'T LET THAT HORSE"
[On Marc Chagall's *Equestrienne*, 1931]

Don't let that horse
eat that violin

cried Chagall's mother

But he
kept right on
painting

And became famous

And kept on painting
The Horse With Violin in Mouth

And when he finally finished it
he jumped up upon the horse
and rode away
waving the violin

And then with a low bow gave it
to the first naked nude he ran across

And there were no strings
attached

LAWRENCE FERLINGHETTI (1919–) 95

THE STARRY NIGHT

That does not keep me from having a terrible need of –
shall I say the word – religion. Then I go out at night to
paint the stars.

VINCENT VAN GOGH in a letter to his brother

The town does not exist
except where one black-haired tree slips
up like a drowned woman into the hot sky.
The town is silent. The night boils with eleven stars.
Oh starry starry night! This is how
I want to die.

It moves. They are all alive.
Even the moon bulges in its orange irons
to push children, like a god, from its eye.
The old unseen serpent swallows up the stars.
Oh starry starry night! This is how
I want to die:

into that rushing beast of the night,
sucked up by that great dragon, to split
from my life with no flag,
no belly,
no cry.

NUDE DESCENDING A STAIRCASE
[On Marcel Duchamp]

Toe upon toe, a snowing flesh,
A gold of lemon, root and rind,
She sifts in sunlight down the stairs
With nothing on. Nor on her mind.

We spy beneath the banister
A constant thresh of thigh on thigh.
Her lips imprint the swinging air
That parts to let her parts go by.

One-woman waterfall, she wears
Her slow descent like a long cape
And pausing, on the final stair
Collects her motions into shape.

From TWO BACKGROUNDS
[On Jan van Eyck's *Madonna of Chancellor Rolin*]

Here by the ample river's margent sweep,
Bosomed in tilth and vintage to her walls,
A tower-crowned Cybele in armoured sleep
The city lies, fat plenty in her halls,
With calm parochial spires that hold in fee
The friendly gables clustered at their base,
And, equipoised o'er tower and market-place,
The Gothic minster's winged immensity;
And, in that narrow burgh, with equal mood,
Two placid hearts, to all life's good resigned,
Might, from the altar to the lych-gate, find
Long years of peace and dreamless plenitude.

CÉZANNE'S PORTS
[On Paul Cézanne's *L'Estaque*]

In the foreground we see time and life
swept in a race
toward the left hand side of the picture
where shore meets shore.

But that meeting place
isn't represented;
it doesn't occur on the canvas.

For the other side of the bay
is Heaven and Eternity,
with a bleak white haze over its mountains.

And the immense water of L'Estaque is a go-between
for minute rowboats.

ALLEN GINSBERG (1926–97)

MATISSE'S DANCE

A break in the circle dance of naked women,
dropped stitch between the hands
of the slender figure stretching too hard
to reach her joyful sisters.

Spirals of glee sail from the arms
of the tallest woman. She pulls
the circle around with her fire.
What has she found that she doesn't
keep losing, her torso
a green-burning torch?

Grass mounds curve ripely beneath
two others who dance beyond the blue.
Breasts swell and multiply and
rhythms rise to a gallop.

Hurry, frightened one, and grab on – before
the stich is forever lost, before the dance
unravels and a black sun swirls from that space.

A FARM PICTURE

Through the ample open door of the peaceful
 country barn,
A sunlit pasture filled with cattle and horses feeding,
And haze and vista, and the far horizon fading away.

THE VETERAN IN A NEW FIELD
From *Four Civil War Paintings by Winslow Homer*

A lone man scything wheat

His back is turned to us, his white shirt
the brightest thing in the painting.
Old trousers, leather army suspenders.
Before him the red wheat bends,
the sky is cloudless, smokeless, and blue.
Where he has passed, the hot stalks spread
in streaks, like a shell exploding, but that is
behind him. With stiff, bony shoulders
he mows his way into the colors of summer.

THE PORTRAIT GALLERY

VERMEER'S LITTLE GIRL

Vermeer's little girl, now famous,
watches me. A pearl watches me.
The lips of Vermeer's little girl
are red, moist, and shining.

Oh Vermeer's little girl, oh pearl,
blue turban: you are all light
and I am made of shadow.
Light looks down on shadow
with forbearance, perhaps pity.

ADAM ZAGAJEWSKI (1945–)
TRANS. CLARE CAVANAGH

LADY WITH AN ERMINE
[On Leonardo da Vinci]

 In the snow, white noise, a gathering
Of foxes oddly standing still in the milk broth
 of oblivion.

 In the keep at Castlestrange, an ermine pelt
 in the shape
Of an ermine animal, but empty, slung over the carved

 Oak chair, carelessly & keeping no
One warm.

REMBRANDT'S LATE SELF-PORTRAITS

You are confronted with yourself. Each year
The pouches fill, the skin is uglier.
You give it all unflinchingly. You stare
Into yourself, beyond. Your brush's care
Runs with self-knowledge. Here

Is a humility at one with craft.
There is no arrogance. Pride is apart
From this self-scrutiny. You make light drift
The way you want. Your face is bruised and hurt
But there is still love left.

Love of the art and others. To the last
Experiment went on. You stared beyond
Your age, the times. You also plucked the past
And tempered it. Self-portraits understand,
And old age can divest,

With truthful changes, us of fear of death.
Look, a new anguish. There, the bloated nose,
The sadness and the joy. To paint's to breathe,
And all the darknesses are dared. You chose
What each must reckon with.

ELIZABETH JENNINGS (1926–2001)

THE CROSS OF SNOW

In the long, sleepless watches of the night,
 A gentle face – the face of one long dead –
 Looks at me from the wall, where round its head
 The night-lamp casts a halo of pale light.
Here in this room she died; and soul more white
 Never through martyrdom of fire was led
 To its repose; nor can in books be read
 The legend of a life more benedight.
There is a mountain in the distant West
 That, sun-defying, in its deep ravines
 Displays a cross of snow upon its side.
Such is the cross I wear upon my breast
 These eighteen years, through all the
 changing scenes
 And seasons, changeless since the day she died.

WITCHCRAFT BY A PICTURE

I fix mine eye on thine, and there
Pity my picture burning in thine eye;
My picture drowned in a transparent tear,
When I look lower I espy.
Hadst thou the wicked skill
By pictures made and mard, to kill,
How many ways mightst thou perform thy will?

But now I have drunk thy sweet salt tears,
And though thou pour more I'll depart;
My picture vanished, vanish fears
That I can be endamaged by that art;
Though thou retain of me
One picture more, yet that will be,
Being in thine own heart, from all malice free.

ON THE PORTRAIT OF A WOMAN
ABOUT TO BE HANGED

Comely and capable one of our race,
Posing there in your gown of grace,
 Plain, yet becoming;
 Could subtlest breast
 Ever have guessed
What was behind that innocent face,
 Drumming, drumming!

Would that your Causer, ere knoll your knell
For this riot of passion, might deign to tell
 Why, since It made you
 Sound in the germ,
 It sent a worm
To madden Its handiwork, when It might well
 Not have assayed you,

Not have implanted, to your deep rue,
The Clytaemnestra spirit in you,
 And with purblind vision
 Sowed a tare
 In a field so fair,
And a thing of symmetry, seemly to view,
 Brought to derision!

FORMERLY A SLAVE

an idealized portrait, by E. Vedder, in the spring exhibition
of the National Academy, 1865

The sufferance of her race is shown,
　　And retrospect of life,
Which now too late deliverance dawns upon;
　　Yet is she not at strife.

Her children's children they shall know
　　The good withheld from her;
And so her reverie takes prophetic cheer –
　　In spirit she sees the stir

Far down the depth of thousand years,
　　And marks the revel shine;
Her dusky face is lit with sober light,
　　Sibylline, yet benign.

From BEFORE THE MIRROR
(*Verses written under a Picture*)
Inscribed to J. A. Whistler
[On James Whistler's *Symphony in White*, no. 2]

Glad, but not flushed with gladness,
 Since joys go by;
Sad, but not bent with sadness,
 Since sorrows die;
Deep in the gleaming glass
She sees all past things pass,
 And all sweet life that was lie down and lie.

There glowing ghosts of flowers
 Draw down, draw nigh;
And wings of swift spent hours
 Take flight and fly;
She sees by formless gleams,
She hears across cold streams,
 Dead mouths of many dreams that sing and sigh.

Face fallen and white throat lifted,
 With sleepless eye
She sees old loves that drifted,
 She knew not why,
Old loves and faded fears
Float down a stream that hears
 The flowing of all men's tears beneath the sky.

THREE FOR THE MONA LISA

1

It is not what she did
at 10 o'clock
last evening

accounts for the smile

It is
that she plans
to do it again

tonight.

2

Only the mouth
all those years
ever

letting on.

3

It's not the mouth
exactly

it's not the eyes
exactly either

it's not even
exactly a smile

But, whatever,
I second the motion.

JOHN STONE (1936–2008) 113

IN AN ARTIST'S STUDIO

One face looks out from all his canvases,
One selfsame figure sits or walks or leans:
We found her hidden just behind those screens,
That mirror gave back all her loveliness.
A queen in opal or in ruby dress,
A nameless girl in freshest summer-greens,
A saint, an angel – every canvas means
The same one meaning, neither more nor less.
He feeds upon her face by day and night,
And she with true kind eyes looks back on him,
Fair as the moon and joyful as the light:
Not wan with waiting, not with sorrow dim;
Not as she is, but was when hope shone bright;
Not as she is, but as she fills his dream.

From HAMLET
Act III, sc. IV

Hamlet. Look here, upon this picture, and on this.
The counterfeit presentment of two brothers.
See, what a grace was seated on this brow;
Hyperion's curls; the front of Jove himself;
An eye like Mars, to threaten and command;
A station like the herald Mercury
New-lighted on a heaven-kissing hill;
A combination and a form indeed,
Where every god did seem to set his seal,
To give the world assurance of a man:
This was your husband. Look you now, what follows:
Here is your husband; like a mildew'd ear,
Blasting his wholesome brother. Have you eyes?
Could you on this fair mountain leave to feed,
And batten on this moor? Ha! have you eyes?
You cannot call it love; for at your age
The hey-day in the blood is tame, it's humble,
And waits upon the judgement: and what judgement
Would step from this to this? Sense, sure, you have,
Else could you not have motion; but sure, that sense
Is apoplex'd; for madness would not err,
Nor sense to ecstasy was ne'er so thrall'd
But it reserved some quantity of choice,
To serve in such a difference. What devil was't
That thus hath cozen'd you at hoodman-blind?

WILLIAM SHAKESPEARE (1564–1616) 115

MY LAST DUCHESS
Ferrara

That's my last Duchess painted on the wall,
Looking as if she were alive. I call
That piece a wonder, now: Frà Pandolf's hands
Worked busily a day, and there she stands.
Will't please you sit and look at her? I said
"Frà Pandolf" by design, for never read
Strangers like you that pictured countenance,
The depth and passion of its earnest glance,
But to myself they turned (since none puts by
The curtain I have drawn for you, but I)
And seemed as they would ask me, if they durst,
How such a glance came there; so, not the first
Are you to turn and ask thus. Sir, 'twas not
Her husband's presence only, called that spot
Of joy into the Duchess' cheek: perhaps
Frà Pandolf chanced to say "Her mantle laps
Over my lady's wrist too much," or "Paint
Must never hope to reproduce the faint
Half-flush that dies along her throat": such stuff
Was courtesy, she thought, and cause enough
For calling up that spot of joy. She had
A heart – how shall I say? – too soon made glad,
Too easily impressed; she liked whate'er
She looked on, and her looks went everywhere.

Sir, 'twas all one! My favour at her breast,
The dropping of the daylight in the West,
The bough of cherries some officious fool
Broke in the orchard for her, the white mule
She rode with round the terrace – all and each
Would draw from her alike the approving speech,
Or blush, at least. She thanked men, – good! but thanked
Somehow – I know not how – as if she ranked
My gift of a nine-hundred-years-old name
With anybody's gift. Who'd stoop to blame
This sort of trifling? Even had you skill
In speech – (which I have not) – to make your will
Quite clear to such an one, and say, "Just this
Or that in you disgusts me; here you miss,
Or there exceed the mark" – and if she let
Herself be lessoned so, nor plainly set
Her wits to yours, forsooth, and made excuse,
– E'en then would be some stooping; and I choose
Never to stoop. Oh sir, she smiled, no doubt,
Whene'er I passed her; but who passed without
Much the same smile? This grew; I gave commands;
Then all smiles stopped together. There she stands
As if alive. Will't please you rise? We'll meet
The company below, then. I repeat,

The Count your master's known munificence
Is ample warrant that no just pretence
Of mine for dowry will be disallowed;
Though his fair daughter's self, as I avowed
At starting, is my object. Nay, we'll go
Together down, sir. Notice Neptune, though,
Taming a sea-horse, thought a rarity,
Which Claus of Innsbruck cast in bronze for me!

PICTURE OF A 23-YEAR-OLD PAINTED BY HIS FRIEND OF THE SAME AGE, AN AMATEUR

He finished the picture yesterday noon.
Now he looks at it detail by detail. He's painted him
wearing an unbuttoned gray jacket,
no vest, tieless, with a rose-colored
shirt, open, allowing a glimpse
of his beautiful chest and neck.
The right side of his forehead is almost covered
by his hair, his lovely hair
(done in the style he's recently adopted).
He's managed to capture perfectly the sensual note
he wanted when he did the eyes,
when he did the lips . . .
That mouth of his, those lips
so ready to satisfy a special kind of erotic pleasure.

CONSTANTINE P. CAVAFY (1863–1933) 119
TRANS. EDMUND KEELEY AND PHILIP SHERRARD

WASTED DAYS
(From a picture painted by Miss V. T.)

A fair slim boy not made for this world's pain,
 With hair of gold thick clustering round his ears,
 And longing eyes half veiled by foolish tears
Like bluest water seen through mists of rain;
Pale cheeks whereon no kiss hath left its stain,
 Red under-lip drawn in for fear of Love,
 And white throat whiter than the breast of dove –
Alas! alas! if all should be in vain.
Corn-fields behind, and reapers at a-row
In weariest labour, toiling wearily,
To no sweet sound of laughter, or of lute;
And careless of the crimson sunset-glow,
The boy still dreams; nor knows that night is night,
And in the night-time no man gathers fruit.

MEMLING'S SIBYLLE SAMBETHA

Seated on my chair
I work on a lace collar for my father,
when the young man thrusts open the hatch.
He falls to his knees
and says it is for me he has come.
"Never have I beheld a woman like you," he says.
"From your face shines the light I have only seen
in the stained glass of cathedrals."
The spools between my fingers become tangled.
I look down and up and then down again.
Never have I thought of myself as a woman,
never seen myself as attractive.
The young man's look is so full of entreaty,
his lips are so trembly,
his eyes so misty,
that I permit him to touch my hands.

ANNE PROVOOST (1964–) 121
TRANS. JOHN NIEUWENHUIZEN

From LUCRECE

This picture she advisedly perus'd,
And chid the painter for his wondrous skill,
Saying some shape in Sinon's was abus'd:
So fair a form lodg'd not a mind so ill.
And still on him she gaz'd, and gazing still,
 Such signs of truth in his plain face she spied,
 That she concludes the picture was belied.

"It cannot be," quoth she, "that so much guile," –
She would have said, – "can lurk in such a look."
But Tarquin's shape came in her mind the while,
And from her tongue "can lurk" from "cannot" took:
"It cannot be" she in that sense forsook,
 And turn'd it thus: "It cannot be, I find,
 But such a face should bear a wicked mind."

AMERICAN GOTHIC
after the painting by Grant Wood

Just outside the frame
there has to be a dog
chickens, cows and hay

and a smokehouse
where a ham in hickory
is also being preserved

Here for all time
the borders of the Gothic window
anticipate the ribs

of the house
the tines of the pitchfork
repeat the triumph

of his overalls
and front and center
the long faces, the sober lips

above the upright spines
of this couple
arrested in the name of art

These two
by now
the sun this high

ought to be
in mortal time
about their businesses

Instead they linger here
within the patient fabric
of the lives they wove

he asking the artist silently
how much longer
and worrying about the crops

she no less concerned about the crops
but more to the point just now
whether she remembered

to turn off the stove.

THE SCULPTURE GARDEN

ARCHAIC TORSO OF APOLLO

We cannot know his legendary head
with eyes like ripening fruit. And yet his torso
is still suffused with brilliance from inside,
like a lamp, in which his gaze, now turned to low,

gleams in all its power. Otherwise
the curved breast could not dazzle you so, nor could
a smile run through the placid hips and thighs
to that dark center where procreation flared.

Otherwise this stone would seem defaced
beneath the translucent cascade of the shoulders
and would not glisten like a wild beast's fur:

would not, from all the borders of itself,
burst like a star: for here there is no place
that does not see you. You must change your life.

RAINER MARIA RILKE (1875–1926)
TRANS. STEPHEN MITCHELL

OZYMANDIAS

I met a traveller from an antique land
Who said: – Two vast and trunkless legs of stone
Stand in the desert. Near them on the sand,
Half sunk, a shatter'd visage lies, whose frown
And wrinkled lip and sneer of cold command
Tell that its sculptor well those passions read
Which yet survive, stamp'd on these lifeless things,
The hand that mock'd them and the heart that fed.
And on the pedestal these words appear:
"My name is Ozymandias, king of kings:
Look on my works, ye mighty, and despair!"
Nothing beside remains: round the decay
Of that colossal wreck, boundless and bare,
The lone and level sands stretch far away.

RODIN'S THINKER

With his chin fallen on his rough hand,
the Thinker, remembering that his flesh is of the grave,
mortal flesh, naked before its fate,
flesh that hates death, trembled for beauty.

And he trembled for love, his whole ardent spring,
and now in autumn, he is overcome with truth and
 sadness.
"We must die" passes across his brow,
in every piercing trumpet sound, when night begins
 to fall.

And in his anguish, his long suffering muscles split.
The furrows of his flesh are filled with terrors.
It splits, like the autumn leaf before the mighty Lord

who calls it with trumpet calls . . . And there is no
 tree twisted
by the sun in the plain, nor lion wounded on its side,
as tense as this man who meditates on death.

GABRIELA MISTRAL (1889–1957) 129
TRANS. GUSTAVO ALFARO

THE VICTORY OF SAMOTHRACE

The missing head tells yet of the sacred day
on which, in winds of triumph, multitudes
paraded, inflamed, before the simulacrum
that sent Greeks seething in the Athenian streets.
This eminent image has no eyes, and sees,
no mouth, and calls out the supremest cry,
no arms, and sets the whole lyre in vibration;
the marble wings embrace the infinite.

TRANS. JOHN HOLLANDER

ON SEEING THE ELGIN MARBLES

My spirit is too weak – mortality
 Weighs heavily on me like unwilling sleep,
 And each imagined pinnacle and steep
Of godlike hardship tells me I must die
Like a sick eagle looking at the sky.
 Yet 'tis a gentle luxury to weep
 That I have not the cloudy winds to keep
Fresh for the opening of the morning's eye.
Such dim-conceived glories of the brain
 Bring round the heart an indescribable feud;
So do these wonders a most dizzy pain
 That mingles Grecian grandeur with the rude
Wasting of old Time – with a billowy main –
 A sun – a shadow of a magnitude.

THE NEW COLOSSUS

Not like the brazen giant of Greek fame,
With conquering limbs astride from land to land;
Here at our sea-washed, sunset gates shall stand
A mighty woman with a torch, whose flame
Is the imprisoned lightning, and her name
Mother of Exiles. From her beacon-hand
Glows world-wide welcome; her mild eyes command
The air-bridged harbor that twin cities frame.
"Keep, ancient lands, your storied pomp!" cries she
With silent lips. "Give me your tired, your poor,
Your huddled masses yearning to breathe free,
The wretched refuse of your teeming shore.
Send these, the homeless, the tempest-tost to me,
I lift my lamp beside the golden door!"

ON A BAS-RELIEF OF PELOPS
AND HIPPODAMEIA
Which was Wrecked and Lay Many Years Under the Sea

Thus did a nameless and immortal hand
 Make of rough stone, the thing least like to life,
 The husband and the wife
That the Most High, ere His creation, planned.
Hundreds of years they lay, unsunned, unscanned,
 Where the waves cut more smoothly than the knife,
 What time the winds tossed them about in strife
And filled those lips and eyes with the soft sand.
Art, that from Nature stole the human form
 By slow device of brain, by simple strength,
Lent it to Nature's artless force to keep.
So, with the human sculptor, wrought the storm
 To round those lines of beauty, till at length
A perfect thing was rescued from the deep.

MARY ELIZABETH COLERIDGE (1861–1907) 133
PSEUDO. ANODOS

MAMELLES
From *Articulated Lair:*
Poems for Louise Bourgeois

A stretched frieze

poured hill to hill
to a milked horizon

The fetish rubs close
is graspable, laps
at the taffy-pulling rack

She acquiesces to divine rights

This poultice will heave
many handled
rose-sucking waves

for a garish thirst

Erosion in evidence

Post-partum depression

Dismembering nestler

to a precipice

RECLINING FIGURE

Then the knee of the wave
turned to stone.

By the cliff of her flank
I anchored,

in the darkness of harbors
laid-by.

Henry Moore

A CALDER

To raise an iron tree
Is a wooden irony,
But to cause it to sail
In a clean perpetual way
Is to play
Upon the spaces of the scale.
Climbing the stairs we say,
Is it work or is it play?

Alexander Calder made it
Work and play:
Leaves that will never burn
But were fired to be born,
Twigs that are stiff with life
And bend as to the magnet's breath,
Each segment back to back,
The whole a hanging burst of flak.

Still the base metals,
Touched by autumnal paint
Fall through no autumn
But, turning, feint
In a fall beyond trees,
Where forests are not wooded,
There is no killing breeze,
And iron is blooded.

HIRAM POWERS' GREEK SLAVE

They say Ideal beauty cannot enter
The house of anguish. On the threshold stands
An alien Image with enshackled hands,
Called the Greek Slave! as if the artist meant her
(That passionless perfection which he lent her,
Shadowed not darkened where the sill expands)
To so confront man's crimes in different lands
With man's ideal sense. Pierce to the centre,
Art's fiery finger! and break up ere long
The serfdom of this world! appeal, fair stone,
From God's pure heights of beauty against
 man's wrong!
Catch up in thy divine face, not alone
East griefs but west, and strike and shame the strong,
By thunders of white silence, overthrown.

ELIZABETH BARRETT BROWNING (1806–61) 137

THE DEAD CHRIST
From *Michael Angelo*

MICHAEL ANGELO'S Studio. MICHAEL ANGELO with a light, working upon the Dead Christ. Midnight.

MICHAEL ANGELO

O Death, why is it I cannot portray
Thy form and features? Do I stand too near thee?
Or dost thou hold my hand, and draw me back,
As being thy disciple, not thy master?
Let him who knows not what old age is like
Have patience till it comes, and he will know.
I once had skill to fashion Life and Death
And Sleep, which is the counterfeit of Death;
And I remember what Giovanni Strozzi
Wrote underneath my statue of the Night
In San Lorenzo, ah, so long ago!
Grateful to me is sleep! More grateful now
Than it was then; for all my friends are dead;
And she is dead, the noblest of them all.
I saw her face, when the great sculptor Death,
Whom men should call Divine, had at a blow
Stricken her into marble; and I kissed
Her cold white hand. What was it held me back
From kissing her fair forehead, and those lips,
Those dead, dumb lips? Grateful to me is sleep!

THE "MOSES" OF MICHAEL ANGELO

And who is He that, sculptured in huge stone,
 Sitteth a giant, where no works arrive
 Of straining Art, and hath so prompt and live
The lips, I listen to their very tone?
Moses is He – Ay, that, makes clearly known
 The chin's thick boast, and brow's prerogative
 Of double ray: so did the mountain give
Back to the world that visage, God was grown
Great part of! Such was he when he suspended
 Round him the sounding and vast waters; such
 When he shut sea on sea o'er Mizraïm.
And ye, his hordes, a vile calf raised, and bended
 The knee? This Image had ye raised, not much
 Had been your error in adoring him.

ROBERT BROWNING (1812–89) 139

BRANCUSI'S *GOLDEN BIRD*

The toy
becomes the aesthetic archetype

As if
some patient peasant God
had rubbed and rubbed
the Alpha and Omega
of Form
into a lump of metal

A naked orientation
unwinged unplumed
– the ultimate rhythm
has lopped the extremities
of crest and claw
from
the nucleus flight

The absolute act
of art
conformed
to continent sculpture
– bare as the brow of Osiris –
This breast of revelation

An incandescent curve
licked by chromatic flames
in labyrinths of reflections

This gong
of polished hyperaesthesia
shrills with brass
as the aggressive light
strikes
its significance

The immaculate
conception
of the inaudible bird
occurs
in gorgeous reticence...

TO THE FRAGMENT OF A STATUE
OF HERCULES, COMMONLY CALLED
THE TORSO

And dost thou still, thou mass of breathing stone,
(Thy giant limbs to night and chaos hurled)
Still sit as on the fragment of a world;
Surviving all, majestic and alone?
What tho' the Spirits of the North, that swept
Rome from the earth when in her pomp she slept,
Smote thee with fury, and thy headless trunk
Deep in the dust mid tower and temple sunk;
Soon to subdue mankind 'twas thine to rise,
Still, still unquelled thy glorious energies!
Aspiring minds, with thee conversing, caught
Bright revelations of the Good they sought;
By thee that long-lost spell its secret given,
To draw down Gods, and lift the soul to Heaven!

"THESE CHILDREN
SINGING IN STONE"
From *50 poems*
[On Luca della Robbia]

37

these children singing in stone a
silence of stone these
little children wound with stone
flowers opening for

ever these silently lit
tle children are petals
their song is a flower of
always their flowers

of stone are
silently singing
a song more silent
than silence these always

children forever
singing wreathed with singing
blossoms children of
stone with blossoming

eyes
know if a
lit tle
tree listens

forever to always children singing forever
a song made
of silent as stone silence of
song

THE WALKING MAN OF RODIN

Legs hold a torso away from the earth.
And a regular high poem of legs is here.
Powers of bone and cord raise a belly and lungs
Out of ooze and over the loam where eyes look and
 ears hear
And arms have a chance to hammer and shoot and
 run motors.
 You make us
 Proud of our legs, old man.

And you left off the head here,
The skull found always crumbling neighbor of
 the ankles.

CARL SANDBURG (1878–1967) 145

From TRILCE

We struggle to thread ourselves through
 a needle's eye,
face to face, hellbent on winning.
The fourth angle of the circle ammoniafies almost.
Female is continued the male, on the basis
of probable breasts, and precisely
on the basis of how much does not flower!

 Are you that way, Venus of Milo?
You hardly act crippled, pullulating
enwombed in the plenary arms
of existence,
of this existence that neverthelessez
perpetual imperfection.
Venus de Milo, whose cut off, increate
arm swings round and tries to elbow
across greening stuttering pebbles,
ortive nautili, recently crawling
evens, immortal on the eves of.
Lassoer of imminences, lassoer
of the parenthesis.

 Refuse, all of you, to set foot
on the double security of Harmony.
Truly refuse symmetry.

Intervene in the conflict
of points that contend
in the most rutty of jousts
for the leap through the needle's eye!

 So now I feel my little finger
moreover on my left. I see it and think
it shouldn't be me, or at least that it's
in a place where it shouldn't.
And it inspires me with rage and alarms me
and there is no way out of it, except by
pretending that today is Thursday.

Make way for the new odd number
 potent with orphanhood!

CÉSAR VALLEJO (1892–1938) 147
TRANS. CLAYTON ESHLEMAN

VARIETIES OF
ARTISTRY

JOSEPH CORNELL'S *HÔTEL DU NORD*
[boxed assemblage]

The windows of Hôtel du Nord have a view of the
snows of Labrador which are famous for their yellow
sunflowers. The white paint in our room is peeling;
the beds and chairs have gone to China to be
missionaries; the desk clerk is as deaf as a shoe brush.
The hermit architect was thinking about his invalid
brother's toy box and a flytrap in his mother's kitchen.
When somebody knocked, we ran to open. There was
never anyone. The quiet that reigns in the hotel is that
of an Egyptian pyramid in a hundred-year-old post-
card with an address in Oklahoma on the other side.

The sky is blue and so is the ceiling. Glued to the
wall, there's a cut-out of a Renaissance child pointing
to a picture of a camel that could have come out of a
long discontinued breakfast cereal. Above him, hung
from a silver rod by a metal hook, there's a stamp
with a picture of another smaller Renaissance child.
This one appears to be saying his bedtime prayer.
Their father, the Prince, has gone off to stand on the
parapet with his beard on fire.

Time hesitates between dream and reality with the
key in the door; the tongue can't find a word in the
whole wide world. Solitude has a spidery stepladder
which it is going to climb and peek at the boar with
tusks hidden behind the white column. If night ever falls,
the two children will light matches and eat dragon stew.

CHARLES SIMIC (1938–) 151

THE VIRGIN
From *Stained Glass*

Was silent

She was so silent
The clock stopped, at a sheer brink.

So silent
The stars pressed in on her ear-drum
Like children's noses at a window.

A silent
Carving in a never-trodden cavern.

So silent
The Creator woke, sweating fear

And saw her face stretching like a sphincter
Round a swelling cry.

Drop by drop

Like bodiless footsteps

Blood was collecting beneath her.

AUNT JENNIFER'S TIGERS

Aunt Jennifer's tigers prance across a screen,
Bright topaz denizens of a world of green.
They do not fear the men beneath the tree;
They pace in sleek chivalric certainty.

Aunt Jennifer's fingers fluttering through her wool
Find even the ivory needle hard to pull.
The massive weight of Uncle's wedding band
Sits heavily upon Aunt Jennifer's hand.

When Aunt is dead, her terrified hands will lie
Still ringed with ordeals she was mastered by.
The tigers in the panel that she made
Will go on prancing, proud and unafraid.

ADRIENNE RICH (1929–) 153

IT'S ME!
[On Andy Warhol's *Marilyn Diptych*]

Hey!

Over here!

It's me!

The real Marilyn!

Shhh!

Don't tell the others!

They don't know they're fakes!

Hey!

Over here!

It's me!

The real Marilyn!

Shhh!

Don't tell the others!

They don't know they're fakes!

Hey!

Over here!

It's me!

CRAFTSMAN OF WINE BOWLS

On this wine bowl – pure silver,
made for the house of Herakleidis,
where good taste is the rule –
notice these graceful flowers, the streams, the thyme.
In the center I put this beautiful young man,
naked, erotic, one leg still dangling
in the water. O memory, I begged
for you to help me most in making
the young face I loved appear the way it was.
This proved very difficult because
some fifteen years have gone by since the day
he died as a soldier in the defeat at Magnesia.

CONSTANTINE P. CAVAFY (1863–1933) 155
TRANS. EDMUND KEELEY AND PHILIP SHERRARD

SIT A WHILE
[On Romare Bearden's collage,
Black Manhattan]

Sit a while.
What do you hear?
A bird? A bus? A baby's cry?
The shouting of a boy?

 For joy?

Leaves rustling?
 Trains rattling?
 Skateboards rolling?
 A boombox blaring?
A mother calling?
The droning of a car?

 Or ten –
traveling far, then home again,
 like your thoughts
 as you sit
with nothing much to do but
 contemplating it?

From ON THE PICTURE OF TWO DOLPHINS IN A FOUNTAYNE

These dolphins twisting each on either side
For joy leapt up, and gazing there abide;
And whereas other waters fish do bring,
Here from the fishes doe the waters spring,
Who think it is more glorious to give
Than to receive the juice whereby they live.

A COLOURED PRINT BY SHOKEI

It winds along the face of a cliff
 This path which I long to explore,
And over it dashes a waterfall,
 And the air is full of the roar
And the thunderous voice of waters which sweep
In a silver torrent over some steep.

It clears the path with a mighty bound
 And tumbles below and away,
And the trees and the bushes which grow in the rocks
 Are wet with its jewelled spray;
The air is misty and heavy with sound,
And small, wet wildflowers star the ground.

Oh! The dampness is very good to smell,
 And the path is soft to tread,
And beyond the fall it winds up and on,
 While little streamlets thread
Their own meandering way down the hill
Each singing its own little song, until

I forget that 'tis only a pictured path,
 And I hear the water and wind,
And look through the mist, and strain my eyes
 To see what there is behind;
For it must lead to a happy land,
This little path by a waterfall spanned.

ON THE ENGRAVER OF HIS LIKENESS

Looking at the form of its original, you might say, mayhap, that this likeness had been drawn by a tyro's hand; but, friends, since you do not recognize what is modelled here, have a laugh at a caricature by a good-for-nothing artist.

JOHN MILTON (1608–74)

ANTIQUARY

If in his Studie he hath so much care
To'hang all old strange things, let his wife beware.

JOHN DONNE (1572–1631)

HINDU ILLUMINATION

T loping down the stairs at Mellifont.
That end-of-March, half-mad, half-mocking
Duel with O. NR's
Forearms, who taught me pinochle at ten.
E's glow of pure seduction as it stole
Throughout a nature presently
To be reviled by it. (Reviled? Revealed.)
P's helpless laughter. H's body heat...
Remembering all these and more, I smile.

Likewise an artist made his elephant
Entirely of interlocking
Animal and human avatars:
Antelope, archer, lion, duck, each then
Reborn as portion of the whole
Proverbial creature – wisdom, memory –
Shown dancing on a crimson field.
Now, reaching for you in pitch dark, to meet
The mahout's gaze, upon me all this while.

THE EMPEROR'S GARDEN

Once, in the sultry heats of Midsummer,
An Emperor caused the miniature mountains
 in his garden
To be covered with white silk,
That so crowned
They might cool his eyes
With the sparkle of snow.

AMY LOWELL (1874–1925) 161

From THE IDYLLS, I
[ivy-wood cup]

The lip of it is hanged about with curling ivy, ivy freaked with a cassidony which goes twisting and twining among the leaves in the pride of her saffron fruitage. And within this bordure there's a woman, fashioned as a god might fashion her, lapped in a robe and snood about her head. And either side the woman a swain with fair and flowing locks, and they bandy words the one with the other. Yet her heart is not touched by aught they say; for now 'tis a laughing glance to this, and anon a handful of regard to that, and for all their eyes have been so long hollow for love of her, they spend their labour in vain. Besides these there's an old fisher wrought on't and a rugged rock, and there stands gaffer gathering up his great net for a cast with a right good will like one that toils might and main. You would say that man went about his fishing with all the strength o's limbs, he stands every sinew in his neck, for all his grey hairs, puffed and swollen; for his strength is the strength of youth.

And but a little removed from master Weather-beat there's a vineyard well laden with clusters red to the ripening, and a little lad seated watching upon a hedge. And on either side of him two foxes; this ranges to and fro along the rows and pilfers all such grapes as be ready

for eating, while that setteth all his cunning at the lad's wallet, and vows he will not let him be till he have set him breaking his fast with but poor victuals to his drink. And all the time the urchin's got star-flower-stalks a-plaiting to a reed for to make him a pretty gin for locusts, and cares never so much, not he, for his wallet or his vines as he takes pleasure in his plaiting. And for an end, mark you, spread all about the cup goes the lissom bear's-foot, a sight worth the seeing with its writhen leaves; 'tis a marvellous work, 'twill amaze your heart.

THEOCRITUS (*c.* 300–260 B.C.) 163
TRANS. J. M. EDMONDS

BODY MASK
Makonde peoples, Tanzania and Mozambique

She comes slow and unsteady
each step a clanking of bells.

She comes, back arched, weary
on her skin flowered with scars

beeswax in relief like the raised
topsoil of a rodent's journey underground;

such pain for beautiful things.

She comes, navel precocious
as her down turned nipples;

you can see the tufts of beard
poking beneath the mask.

She comes, belly a wooden bowl
so boys may know the power

of their seed, and girls
may know the myths

of their making and unmaking.

A man turns into a woman
for a day, stiff, uncertain;

he tamps down the earth
leaving us perplexed

by the seduction of his hips
swinging with a girl's boldness.

THE MASK
for Hermann Haller

Entering my room this morning,
I had forgotten your presence:
mask of an oriental woman
carved by a great sculptor.
Sacred terror of finding there,
where we think we are alone,
more than a face.
And of feeling that my own,
contemplating you,
total face,
could not equal you.

RAINER MARIA RILKE (1875–1926)
TRANS. A. POULIN, JR

ON THE GIFT OF *THE BIRDS OF AMERICA*
BY JOHN JAMES AUDUBON

What you have given me is, of course, elegy: the
 red-shouldered
hawk in among these scattering partridges,
flustered at

such a descent, and the broad-winged one poised
 on the branch
of a pignut, and the pine siskin and the wren are
an inference

we follow in the plummet of the tern which appears
 to be,
from this angle anyway, impossibly fragile and
if we imagine

the franchise of light these camphor-coloured wings
 opened out
once with and are at such a loss for now,
then surely this

is the nature and effect of elegy: the celebration of
 an element
which absence has revealed: it is
our earthliness

we love as we look at them, which we fear to lose,
 which we need
this re-phrasing of the air,
of the ocean

to remind us of: that evening, late in May, the Clare
 hills were
ghostly with hawthorn. Two swans flew over us.
I can still hear

the musical insistence of their wings as they came
 in past
the treetops, near the lake; and we looked up,
rooted to the spot.

READING A LARGE SERVING DISH
(Greek, ca. 400 B.C., Chicago Art Institute)

Persephone white-faced
carries her vegetal cross
on a stalk perpendicular
over her shoulder as she heads
up & out for home
& mother, her brilliant mother.

Closing, Hell's house lies behind her
(and, of course, opening, before).

Four creamy horses
implacably processional
are hauling her chariot
– red-orange on black ceramic –
toward her spring turn of sky.
They head for the edge
of the dish of plenty that honors
her style of exchange (exile for exile)
and her game of rounders (no winners, no losers)
her poverty her plenty.

> The dish itself is Demosthenes' age.
> Its suave lines issue its invitation,
> open-ended, a strange attractor.

It tells you it will
if you eat from it teach
your deepening night to brighten
at the depth where no gesture
is straightforward or false,
and you do not need to expect
you can rise beyond suffering.

WOMAN AT THE PIANO
[On Elie Nadelman's *Woman at the Piano*,
wood, stained and painted]

When the tall thin lady started to play
the notes flew up and out and away:
like the pink in her cheeks and her dress's loops
they rose in curves, they rolled in hoops
till the chickens flew out of the chicken coops,
the rooster crowed, the donkey brayed,
and the cat meowed.
 She raised her hands,
she lifted her feet.

What was she playing?
 An anthem? A hymn?
Nobody knew, but, oh, it was sweet!

How thin she was, how tall and prim,
 but, oh, how she played!

Everything in you went loose inside
and the world of a sudden became so wide
and open and joyous and free
the fish came flying out of the sea,
the mountains knelt,
 the birds went wild.

The lady smiled:

and all you could do was hold on to your seat
and simply say:

"For heaven's sake, lady, play, play!
For heaven's sake,
 lady,
 play!"

CALLIGRAPHY
After Liang T'ung-shu (eighteenth century)

The writing of Li Po-hai
Is like the vermilion bird
And the blue-green dragon.
It drifts slowly as clouds drift;
It has the wide swiftness of wind.
Hidden within it lurk the dragon and the tiger.

The writing of Chia, the official,
Is like the high hat of ceremonial.
It flashes like flowers in the hair,
And its music is the trailing of robes
And the sweet tinkling of jade girdle-pendants.
Because of his distinguished position,
He never says anything not sanctioned by precedent.

PAIR OF SCROLLS
After Ho Shao-chi (nineteenth century)

Shoals of fish assemble and scatter,
Suddenly there is no trace of them.

The single butterfly comes –
Goes –
Comes –
Returning as though urged by love.

AMY LOWELL (1874–1925)

THE LADY AND THE UNICORN
The Cluny Tapestries

I am the unicorn and bow my head
You are the lady woven into history
And here forever we are bound in mystery
Our wine, Imagination, and our bread,
And I the unicorn who bows his head.

You are all interwoven in my history
And you and I have been most strangely wed
I am the unicorn and bow my head
And lay my wildness down upon your knee
You are the lady woven into history.

And here forever we are sweetly wed
With flowers and rabbits in the tapestry
You are the lady woven into history
Imagination is our bridal bed:
We lie ghostly upon it, no word said.

Among the flowers of the tapestry
I am the unicorn and by your bed
Come gently, gently to bow down my head,
Lay at your side this love, this mystery,
And call you lady of my tapestry.

I am the unicorn and bow my head
To one so sweetly lost, so strangely wed:

You sit forever under a small formal tree
Where I forever search your eyes to be

Rewarded with this shining tragedy
And know your beauty was not cast for me,

Know we are woven all in mystery,
The wound imagined where no one has bled,

My wild love chastened to this history
Where I before your eyes, bow down my head.

MAY SARTON (1912–95) 175

AN EGYPTIAN PULLED GLASS
BOTTLE IN THE SHAPE OF A FISH

Here we have thirst
and patience, from the first,
 and art, as in a wave held up for us to see
 in its essential perpendicularity

not brittle but
intense – the spectrum, that
 spectacular and nimble animal the fish,
 whose scales turn aside the sun's sword by
 their polish.

From THE CITY OF DREADFUL NIGHT
[On Albrecht Dürer's engraving,
Dark Angel of Melancholy]

Words cannot picture her; but all men know
 That solemn sketch the pure sad artist wrought
Three centuries and threescore years ago,
 With phantasies of his peculiar thought:
The instruments of carpentry and science
Scattered about her feet, in strange alliance
 With the keen wolf-hound sleeping undistraught;

Scales, hour-glass, bell, and magic square above;
 The grave and solid infant perched beside,
With open winglets that might bear a dove,
 Intent upon its tablets, heavy-eyed;
Her folded wings as of a mighty eagle,
But all too impotent to lift the regal
 Robustness of her earth-born strength and pride;

And with those wings, and that light wreath which seems
 To mock her grand head and the knotted frown
Of forehead charged with baleful thoughts and dreams,
 The household bunch of keys, the housewife's gown
Voluminous, indented, and yet rigid
As if a shell of burnished metal frigid,
 The feet thick shod to tread all weakness down;

The comet hanging o'er the waste dark seas,
　　The massy rainbow curved in front of it,
Beyond the village with the masts and trees;
　　The snaky imp, dog-headed, from the Pit,
Bearing upon its batlike leathern pinions
Her name unfolded in the sun's dominions
　　The "Melencolia" that transcends all wit.

ROMAN FOUNTAIN
Borghese

Two basins, one rising from the other
in the circle of an old marble pool,
and from the one above, water gently bending
down to water, which stands waiting below,

meeting the gentle whisper with its silence,
and secretly, as in the hollow of a hand,
showing its sky behind darkness and green
like some unfamiliar object; while it

spreads out peacefully in its lovely shell
without homesickness, circle after circle,
just sometimes dreamily letting itself down

in trickles on the mossy hangings
to the last mirror, which makes its basin
gently smile from underneath with nuances.

RAINER MARIA RILKE (1875–1926)
TRANS. EDWARD SNOW

THE FIGURE-HEAD

The *Charles-and-Emma* seaward sped,
(Named from the carven pair at prow)
He so smart, and a curly head,
She tricked forth as a bride knows how:
 Pretty stem for the port, I trow!

But iron-rust and alum-spray
And chafing gear, and sun and dew
Vexed this lad and lassie gay,
Tears in their eyes, salt tears nor few;
 And the hug relaxed with the failing glue.

But came in end a dismal night,
With creaking beams and ribs that groan,
A black lee-shore and waters white:
Dropped on the reef, the pair lie prone:
 O, the breakers dance, but the winds they moan!

THE STONE GARDEN
Ryoan-ji, fifteenth century

When world is reduced
To clusters of rock

Strewn on bare sand,
World becomes essence.

> When tame sand is raked
> Into algebras

> Of orderly lines
> And orderly circles,

The wildness is framed –
Each rock is a magnet.

And each has been threaded
As if by haphazard

> And grouped into five
> Spaced constellations.

> The mind hovers here
> On the brink of creation.

Energy flows
From the magical scene,

So changeless and changing
It is never exhausted.

> In autumn a leaf falls
> And makes a notation.

> Sun shafting cloud
> Touches one rock alive.

Spring shadows delve
Pools here and there.

A snow-thatch in winter
Makes other distinctions.

> All things are suspended
> In shifting light and shade –

> All but the theme itself:
> Fifteen rocks and sand

Weaving a silent fugue
Down through the centuries,

So changeless and changing
It is never exhausted.

THE CAROUSEL IN THE PARK

Find it.

Down the park walks, on the path leading
past the sycamores.
There through the trees –

nasturtium rumps, breasts plunging,
lime and violet manes
painted on
what was once the same as now littered
russet on their petrified advance.

Find the sun
in the morning rising later,
the chilled afternoons getting shorter and
after dusk, in the lake, in the park,
the downtown city windows scattering
a galaxy of money
in the water.

And winter coming:

the man-handled indigo necks flexing and
the flared noses
and the heads with their quiffed carving.

And the walks leafless and
the squirrels gone,
the sycamores bare and the lake frozen.

Find the child,
going high and descending there. Up and down.
Up, down again.
Her mittens bright as finger-paints and holding fast
to a crust of weather now: twelve years of age in
a thigh-length coat,
unable to explain a sense of ease in

those safe curves, that seasonless canter.

ARCHITECTURE

FACING IT

My black face fades,
hiding inside the black granite.
I said I wouldn't,
dammit: No tears.
I'm stone. I'm flesh.
My clouded reflection eyes me
like a bird of prey, the profile of night
slanted against morning. I turn
this way – the stone lets me go.
I turn that way – I'm inside
the Vietnam Veterans Memorial
again, depending on the light
to make a difference.
I go down the 58,022 names,
half-expecting to find
my own in letters like smoke.
I touch the name Andrew Johnson;
I see the booby trap's white flash.
Names shimmer on a woman's blouse
but when she walks away
the names stay on the wall.
Brushstrokes flash, a red bird's
wings cutting across my stare.
The sky. A plane in the sky.
A white vet's image floats

closer to me, then his pale eyes
look through mine. I'm a window.
He's lost his right arm
inside the stone. In the black mirror
a woman's trying to erase names:
No, she's brushing a boy's hair.

WITHIN KING'S COLLEGE CHAPEL, CAMBRIDGE

Tax not the royal Saint with vain expense,
With ill-match'd aims the Architect who plann'd
(Albeit labouring for a scanty band
Of white-robed Scholars only) this immense

And glorious work of fine intelligence!
– Give all thou canst; high Heaven rejects the lore
Of nicely-calculated less or more: –
So deem'd the man who fashion'd for the sense

These lofty pillars, spread that branching roof
Self-poised, and scoop'd into ten thousand cells
Where light and shade repose, where music dwells

Lingering – and wandering on as loth to die;
Like thoughts whose very sweetness yieldeth proof
That they were born for immortality.

WILLIAM WORDSWORTH (1770–1850) 189

THE OLD BRIDGE AT FLORENCE

Taddeo Gaddi built me. I am old,
 Five centuries old. I plant my foot of stone
 Upon the Arno, as St. Michael's own
 Was planted on the dragon. Fold by fold
Beneath me as it struggles, I behold
 Its glistening scales. Twice hath it overthrown
 My kindred and companions. Me alone
 It moveth not but is by me controlled.
I can remember when the Medici
 Were driven from Florence. Longer still ago
 The final wars of Ghibelline and Guelph.
Florence adorns me with her jewelry;
 And when I think that Michael Angelo
 Hath leaned on me, I glory in myself.

From CHILDE HAROLD'S PILGRIMAGE
(*Canto IV*)

Arches on arches! as it were that Rome,
Collecting the chief trophies of her line,
Would build up all her triumphs in one dome,
Her Coliseum stands; the moonbeams shine
As 'twere its natural torches, for divine
Should be the light which streams here, to illume
This long-explored but still exhaustless mine
Of contemplation; and the azure gloom
Of an Italian night, where the deep skies assume

Hues which have words, and speak to ye of heaven,
Floats o'er this vast and wondrous monument,
And shadows forth its glory. There is given
Unto the things of earth, which Time hath bent,
A spirit's feeling, and where he hath leant
His hand, but broke his scythe, there is a power
And magic in the ruin'd battlement,
For which the palace of the present hour
Must yield its pomp, and wait till ages are its dower.

From WESTMINSTER ABBEY
JULY 25, 1881

(*The Day of Burial, in the Abbey, of Arthur
Penrhyn Stanley, Dean of Westminster*)

Twelve hundred years and more
Along the holy floor
Pageants have pass'd, and tombs of mighty kings
Efface the humbler graves of Sebert's line,
And, as years sped, the minster-aisles divine
Grew used to the approach of Glory's wings.
Arts came, and arms, and law,
And majesty, and sacred form and fear;
Only that primal guest the fisher saw,
Light, only light, was slow to reappear.

The Saviour's happy light,
Wherein at first was dight
His boon of life and immortality,
In desert ice of subtleties was spent
Or drown'd in mists of childish wonderment,
Fond fancies here, there false philosophy!
And harsh the temper grew
Of men with mind thus darken'd and astray;
And scarce the boon of life could struggle through,
For want of light which should the boon convey.

Yet in this latter time
The promise of the prime
Seem'd to come true at last, O Abbey old!
It seem'd, a child of light did bring the dower
Foreshown thee in thy consecration-hour,
And in thy courts his shining freight unroll'd:
Bright wits, and instincts sure,
And goodness warm, and truth without alloy,
And temper sweet, and love of all things pure,
And joy in light, and power to spread the joy.

PISA'S LEANING TOWER

The Tower in tiers of architraves,
Fair circle over cirque,
A trunk of rounded colonades,
The maker's master-work,
Impends with all its pillared tribes,
And, poising them, debates:
It thinks to plunge, then hesitates;
Shrinks back – yet fain would slide;
Withholds itself – itself would urge;
Hovering, shivering on the verge,
 A would-be suicide!

NOTRE DAME

Where a Roman judged a foreign people
A basilica stands and, first and joyful
Like Adam once, an arch plays with its own ribs:
Groined, muscular, never unnerved.

From outside, the bones betray the plan:
Here flying buttresses ensure
That cumbersome mass shan't crush the walls –
A vault bold as a battering-ram is idle.

Elemental labyrinth, unfathomable forest,
The Gothic soul's rational abyss,
Egyptian power and Christian shyness,
Oak together with reed – and perpendicular as tsar.

But the more attentively I studied,
Notre Dame, your monstrous ribs, your stronghold,
The more I thought: I too one day shall create
Beauty from cruel weight.

OSIP MANDELSTAM (1891–1938) 195
TRANS. JAMES GREENE

TO BROOKLYN BRIDGE

How many dawns, chill from his rippling rest
The seagull's wings shall dip and pivot him,
Shedding white rings of tumult, building high
Over the chained bay waters Liberty –

Then, with inviolate curve, forsake our eyes
As apparitional as sails that cross
Some page of figures to be filed away;
– Till elevators drop us from our day . . .

I think of cinemas, panoramic sleights
With multitudes bent toward some flashing scene
Never disclosed, but hastened to again,
Foretold to other eyes on the same screen;

And Thee, across the harbor, silver-paced
As though the sun took step of thee, yet left
Some motion ever unspent in thy stride, –
Implicitly thy freedom staying thee!

Out of some subway scuttle, cell or loft
A bedlamite speeds to thy parapets,
Tilting there momently, shrill shirt ballooning,
A jest falls from the speechless caravan.

Down Wall, from girder into street noon leaks,
A rip-tooth of the sky's acetylene;

All afternoon the cloud-flown derricks turn...
Thy cables breathe the North Atlantic still.

And obscure as that heaven of the Jews,
Thy guerdon ... Accolade thou dost bestow
Of anonymity time cannot raise:
Vibrant reprieve and pardon thou dost show.

O harp and altar, of the fury fused,
(How could mere toil align thy choiring strings!)
Terrific threshold of the prophet's pledge,
Prayer of pariah, and the lover's cry, –

Again the traffic lights that skim thy swift
Unfractioned idiom, immaculate sigh of stars,
Beading thy path – condense eternity:
And we have seen night lifted in thine arms.

Under thy shadow by the piers I waited;
Only in darkness is thy shadow clear.
The City's fiery parcels all undone,
Already snow submerges an iron year...

O Sleepless as the river under thee,
Vaulting the sea, the prairies' dreaming sod,
Unto us lowliest sometime sweep, descend
And of the curveship lend a myth to God.

HART CRANE (1899–1932) 197

HAGIA SOPHIA

Hagia Sophia – here the Lord commanded
That nations and tsars should halt!
Your dome, according to an eye-witness,
Hangs from heaven as though by a chain.

All centuries take their measure from Justinian:
Out of her shrine, in Ephesus, Diana allowed
One hundred and seven green marble pillars
To be pillaged for his alien gods.

How did your lavish builder feel
When – with lofty hand and soul –
He set the apses and the chapels,
Arranging them at east and west?

A splendid temple, bathing in the peace –
A festival of light from forty windows;
Under the dome, on pendentives, the four Archangels
Sail onwards, most beautiful of all.

And this sage and spherical building
Shall outlive centuries and nations,
And the resonant sobbing of the seraphim
Shall not warp the dark gilt surfaces.

198 OSIP MANDELSTAM (1891–1938)
 TRANS. JAMES GREENE

THE PARTHENON

I

Seen Aloft from Afar

Estranged in site,
Aerial gleaming, warmly white,
You look a suncloud motionless
In noon of day divine;
Your beauty charmed enhancement takes
In Art's long after-shine.

II

Nearer Viewed

Like Lais, fairest of her kind,
In subtlety your form's defined –
The cornice curved, each shaft inclined,
While yet, to eyes that do but revel
　　And take the sweeping view,
Erect this seems, and that a level,
　　To line and plummet true.

Spinoza gazes; and in mind
Dreams that one architect designed
　　Lais – and you!

III

The Frieze

What happy musings genial went
With airiest touch the chisel lent
 To frisk and curvet light
Of horses gay – their riders grave –
Contrasting so in action brave
 With virgins meekly bright,
Clear filing on in even tone
With pitcher each, one after one
 Like water-fowl in flight.

IV

The Last Tile

 When the last marble tile was laid
The winds died down on all the seas;
 Hushed were the birds, and swooned the glade;
 Ictinus sat; Aspasia said
"Hist! – Art's meridian, Pericles!"

From CHILDE HAROLD'S PILGRIMAGE
(*Canto IV*)
[On St Peter's Basilica, Vatican City]

Enter: its grandeur overwhelms thee not;
And why? it is not lessen'd; but thy mind,
Expanded by the genius of the spot,
Has grown colossal, and can only find
A fit abode wherein appear enshrined
Thy hopes of immortality; and thou
Shalt one day, if found worthy, so defined,
See thy God face to face, as thou dost now
His Holy of Holies, nor be blasted by his brow.

Thou movest – but increasing with the advance,
Like climbing some great Alp, which still doth rise,
Deceived by its gigantic elegance;
Vastness which grows – but grows to harmonise –
All musical in its immensities;
Rich marbles – richer painting – shrines where flame
The lamps of gold – and haughty dome which vies
In air with Earth's chief structures, though their frame
Sits on the firm-set ground – and this the clouds
 must claim.

Thou seest not all; but piecemeal thou must break,
　　To separate contemplation, the great whole;
　　And as the ocean many bays will make,
　　That ask the eye – so here condense thy soul
　　To more immediate objects, and control
　　Thy thoughts until thy mind hath got by heart
　　Its eloquent proportions, and unroll
　　In mighty graduations, part by part,
The glory which at once upon thee did not dart,

　　Not by its fault – but thine: Our outward sense
　　Is but of gradual grasp – and as it is
　　That what we have of feeling most intense
　　Outstrips our faint expression; even so this
　　Outshining and o'erwhelming edifice
　　Fools our fond gaze, and greatest of the great
　　Defies at first our Nature's littleness,
　　Till, growing with its growth, we thus dilate
Our spirits to the size of that they contemplate.

Then pause, and be enlighten'd; there is more
In such a survey than the sating gaze
Of wonder pleased, or awe which would adore
The worship of the place, or the mere praise
Of art and its great masters, who could raise
What former time, nor skill, nor thought
 could plan;
The fountain of sublimity displays
Its depth, and thence may draw the mind of man
Its golden sands, and learn what great conceptions can.

From SHAH-JAHAN

You knew, Emperor of India, Shah-Jahan,
 That life, youth, wealth, renown
All float away down the stream of time.
 Your only dream
Was to preserve forever your heart's pain.
 The harsh thunder of imperial power
 Would fade into sleep
 Like a sunset's crimson splendour,
 But it was your hope
That at least a single, eternally-heaved sigh would stay
 To grieve the sky.
 Though emeralds, rubies, pearls are all
But as the glitter of a rainbow tricking out empty air
 And must pass away,
 Yet still one solitary tear
 Would hang on the cheek of time
 In the form
Of this white and gleaming Taj Mahal.

RABINDRANATH TAGORE (1861–1941)
 TRANS. WILLIAM RADICE

From CHILDE HAROLD'S PILGRIMAGE
(*Canto IV*)

I stood in Venice, on the Bridge of Sighs,
A palace and a prison on each hand:
I saw from out the wave her structures rise
As from the stroke of the enchanter's wand:
A thousand years their cloudy wings expand
Around me, and a dying Glory smiles
O'er the far times, when many a subject land
Looked to the wingéd Lion's marble piles,
Where Venice sate in state, throned on her hundred isles!

She looks a sea Cybele, fresh from ocean,
Rising with her tiara of proud towers
At airy distance, with majestic motion,
A ruler of the waters and their powers:
And such she was – her daughters had their dowers
From spoils of nations, and the exhaustless East
Poured in her lap all gems in sparkling showers:
In purple was she robed, and of her feast
Monarchs partook, and deemed their dignity increased.

In Venice Tasso's echoes are no more,
And silent rows the songless gondolier;
Her palaces are crumbling to the shore,
And music meets not always now the ear:

Those days are gone – but Beauty still is here;
States fall, arts fade – but Nature doth not die,
Nor yet forget how Venice once was dear,
The pleasant place of all festivity,
The revel of the earth, the masque of Italy!

PHOTOGRAPHY

PLATE 134. BY EAKINS. "A COWBOY IN
THE WEST. AN UNIDENTIFIED MAN
AT THE BADGER COMPANY RANCH."

His hat, his gun, his gloves, his chair, his place
In the sun. He sits with his feet in a dried-up pool
Of sunlight. His face is the face of a hero
Who has read nothing at all, about heroes.
He is without splendor, utterly without
The amazement of self that glorifies Achilles
The sunlike, the killer. He is without mercy
As he is without the imagination that he is
Without mercy. There is nothing to the East of him
Except the camera, which is almost entirely without
Understanding of what it sees in him.
His hat, his gun, his gloves, his homely and
Heartbreaking canteen, empty on the ground.

DAVID FERRY (1924–)

PHOTOGRAPH

my grandsons
spinning in their joy

universe
keep them turning turning
black blurs against the window
of the world
for they are beautiful
and there is trouble coming
round and round and round

MACHINE DANCE
[On Margaret Bourke-White's
Machine Dance, Moscow Ballet School]

As all the moons to water
 and we obedient
in sync between two suits we sit
 we kneel we stand.

One suit of blue and one of soot
 a train racing
toward a windrowed view.
 I am a camera's rein

tracing the pause diminished
 between the shuddered
clicks. F-stopped and pushed into the now.

 We came we read we tilted
our head and all in unison.
 All for one and one
as a white shirt can be a sun

 to black. We were ballet
as now we are a map
 machine of history
holding on. Some of us are mere idea.

We wait for break
to sweep us to a small café next door
 where waiters bring us coffees
on trays of tempered steel.

 We sit in twos and take it.
We say in French, Pour nous
and then we say, Pour more.

WAR PHOTOGRAPH

A naked child is running
along the path toward us,
her arms stretched out,
her mouth open,
the world turned to trash
behind her.

She is running from the smoke
and the soldiers, from the bodies
of her mother and little sister
thrown down into a ditch,
from the blown-up bamboo hut
from the melted pots and pans.
And she is also running from the gods
who have changed the sky to fire
and puddled the earth with skin and blood.
She is running – my god – to us,
10,000 miles away,
reading the caption
beneath her picture
in a weekly magazine.
All over the country
we're feeling sorry for her
and being appalled at the war
being fought in the other world.

She keeps on running, you know,
after the shutter of the camera
clicks. She's running to us.
For how can she know,
her feet beating a path
on another continent?
How can she know
what we really are?
From the distance, we look
so terribly human.

"SOMETHING APPROACHES..."
[On Ander Gunn's photograph of an old, homeless woman]

Something approaches, about
which she has heard a good deal.
Her deaf ears have caught it, like
a silence in the wainscot
by her head. Her flesh has felt
a chill in her feet, a draught
in her groin. She has watched it
like moonlight on the frayed wood
stealing toward her
floorboard by floorboard. Will it hurt?

Let it come, it is
the terror of full repose,
and so no terror.

Poking around the rubbish,
she can't find what she wants.

Near Maidstone once, hop-picking
with the four babies and Tom,
she worked all day along the green
alleys, among the bins,
in the dim leafy light of
the overhanging vines.

In the village, shopkeepers
put cages on their counters
to prevent snatching. But Tom
took something! What was it?

All in the rubbish heap now,
some rotting, most clean vanished.

PORTRAIT OF MY FATHER
AS A YOUNG MAN

In the eyes: dream. The brow as if it could feel
something far off. Around the lips, a great
freshness — seductive, though there is no smile.
Under the rows of ornamental braid
on the slim Imperial officer's uniform:
the saber's basket-hilt. Both hands stay
folded upon it, going nowhere, calm
and now almost invisible, as if they
were the first to grasp the distance and dissolve.
And all the rest so curtained with itself,
so cloudy, that I cannot understand
this figure as it fades into the background –.

Oh quickly disappearing photograph
in my more slowly disappearing hand.

RAINER MARIA RILKE (1875–1926) 217
TRANS. STEPHEN MITCHELL

ON THE PHOTOGRAPH OF
A CORPS COMMANDER

Ay, man is manly. Here you see
 The warrior-carriage of the head,
And brave dilation of the frame;
 And lighting all, the soul that led
In Spottsylvania's charge to victory
 Which justifies his fame.

A cheering picture. It is good
 To look upon a Chief like this,
In whom the spirit moulds the form.
 Here favoring Nature, oft remiss,
With eagle mien expressive has endued
 A man to kindle strains that warm.

Trace back his lineage, and his sires,
 Yeoman or noble, you shall find
Enrolled with men of Agincourt,
 Heroes who shared great Harry's mind.
Down to us come the knightly Norman fires,
 And front the Templars bore.

Nothing can lift the heart of man
 Like manhood in a fellow-man.
The thought of heaven's great King afar
 But humbles us – too weak to scan;
But manly greatness men can span,
 And feel the bonds that draw.

OUTSIDER ART

From GIRLS ON THE RUN
after Henry Darger
[Illustrated manuscript, *The Story of the
Vivian Girls . . .*]

A great plane flew across the sun,
and the girls ran along the ground.
The sun shone on Mr. McPlaster's face, it was green
　　like an elephant's.

Let's get out of here, Judy said.
They're getting closer, I can't stand it.
But you know, our fashions are in fashion
only briefly, then they go out
and stay that way for a long time. Then they come
　　back in
for a while. Then, in maybe a million years, they go
　　out of fashion
and stay there.
Laure and Tidbit agreed,
with the proviso that after that everyone would
　　become fashion
again for a few hours. Write it now, Tidbit said,
before they get back. And, quivering, I took the pen.

Drink the beautiful tea
before you slop sewage over the horizon, the Principal
　　directed.

OK, it's calm now, but it wasn't two minutes ago.
 What do you want me to do, said Henry,
I am no longer your serf,
and if I was I wouldn't do your bidding. That is
 enough, sir.
You think you can lord it over every last dish of
 oatmeal
on this planet, Henry said. But wait till my ambition
comes a cropper, whatever that means, or bursts into
 feathered bloom
and burns on the shore. Then the kiddies dancing
 sidewise
declared it a treat, and the ice-cream gnomes slurped
 their last that day.

ART BRUT

Judith Scott, in memoriam 1943–2005
[Fiber art, wrapping, found objects]

Her bundled woebegones,
Her sheltered primevals,
With a stapler lodged in the brain,
Torso stuffed with a corkscrew,
Sister's lost car keys, child's left shoe,
Or bits of foam, pages from a book,
And the broken back of a chair.
Give up all hope for a better past.
Judy pulls the living from the dead!
Whatever is at her slippered feet,
Within her ravenous, flower-girl grasp –
The process is unstoppable,
The process is humming.

EMILY FRAGOS (1949–) 223

GIRL THINKING
[Stone carvings]

Once I was a block of stone
in Will Edmondson's yard.
I didn't look like *me* at all.
I waited for what seemed forever,
and then I felt a *tap, tap, tap*.
It was Will Edmondson, taking
a hammer and chisel to me.

> *Make me a girl*, I wished.
> *A girl with a space of quiet around her,*
> *a girl with time to dream her dreams.*
> And he did. He did!

You see, I don't want to grow up,
marry, and have a pack of children.
I don't want to spend my days
cooking, cleaning, and washing clothes.
I want to be who I am now
forever, and I will. I will!
Will Edmondson made sure of that.

FIGURE WITH HAT
James Castle (1899–1977)
[Drawings, paper/string constructions]

Face split in two, the stake of black soot and spit
running up and down the body. Nothing but the grit
it takes to keep going in this life, the lonely pitch,
the Christ on his raw wood, the undertaker in his stiff
black suit ... Earthen as Idaho, mute, Castle scowls.
He'll show his drawings to kin across the way and if
they laugh, to hell with them. Nothing to see here,
missy. You're kidding yourself if you think there is.

EMILY FRAGOS (1949–) 225

DON'T SILENCE YOURSELF,
NO TE CALLES
[Drawings, collage]

He took some words from the bowl
and placed them on the table
No te calles

I took some too
placed them near to his words
 Martín Ramírez

After, slowly, slowly
from childhood
towards him followed my footsteps

circling sometimes
sometimes falling in a quite practical way
to sleep to speak

PAINTER AS POET

GRATEFUL IS SLEEP
[On Michelangelo's figure of *Night*
from the Medici tomb]

Grateful is Sleep, more grateful still to be
Of marble; for while shameless wrong and woe
Prevail 'tis best to neither hear nor see:
Then wake me not, I pray you. Hush, speak low.

MICHELANGELO BUONARROTI (1475–1564) 229
TRANS. WILLIAM WORDSWORTH

THE SLAVE SHIP
[Lines attached to Turner's painting,
*Slavers Throwing Overboard the Dead and
the Dying – Typhon Coming On*]

Aloft all hands, strike the top-masts and belay;
Yon angry setting sun and fierce-edged clouds
 Declare the Typhon's coming.
 Before it sweeps your deck throw overboard
 The dead and dying – ne'er heed their chains.
 Hope, Hope, fallacious Hope!
 Where is thy market now?

ON LONDON, 1809
[On Turner's painting, *London from Greenwich Park*]

Where burthen'd Thames reflects the crowded sail,
Commercial care and busy toils prevail,
Whose murky veil, aspiring to the skies,
Obscures thy beauty, and thy form denies,
Save where thy spires pierce the doubtful air,
As gleams of hope amidst a world of care.

BODY'S BEAUTY
[On D. G. Rossetti's painting *Lady Lilith*]

Of Adam's first wife, Lilith, it is told
 (The witch he loved before the gift of Eve,)
 That, ere the snake's, her sweet tongue could deceive,
And her enchanted hair was the first gold.
And still she sits, young while the earth is old,
 And, subtly of herself contemplative,
 Draws men to watch the bright web she can weave,
Till heart and body and life are in its hold.

The rose and poppy are her flowers; for where
 Is she not found, O Lilith, whom shed scent
And soft-shed kisses and soft sleep shall snare?
 Lo! as that youth's eyes burned at thine, so went
 Thy spell through him, and left his straight neck bent
And round his heart one strangling golden hair.

DANTE GABRIEL ROSSETTI (1828–82) 231

HOLY THURSDAY
[Printed with an illustration by Blake]

Is this a holy thing to see
In a rich and fruitful land,
Babes reduced to misery
Fed with cold and usurous hand?

Is that trembling cry a song?
Can it be a song of joy?
And so many children poor?
It is a land of poverty!

And their sun does never shine.
And their fields are bleak & bare.
And their ways are fill'd with thorns.
It is eternal winter there.

For where-e'er the sun does shine,
And where-e'er the rain does fall:
Babe can never hunger there,
Nor poverty the mind appall.

THE TYGER
[Printed with an illustration by Blake]

Tyger! Tyger! burning bright
In the forests of the night,
What immortal hand or eye
Could frame thy fearful symmetry?

In what distant deeps or skies
Burnt the fire of thine eyes?
On what wings dare he aspire?
What the hand, dare sieze the fire?

And what shoulder, & what art,
Could twist the sinews of thy heart?
And when thy heart began to beat,
What dread hand? & what dread feet?

What the hammer? what the chain?
In what furnace was thy brain?
What the anvil? what dread grasp
Dare its deadly terrors clasp?

When the stars threw down their spears,
And water'd heaven with their tears,
Did he smile his work to see?
Did he who made the Lamb make thee?

Tyger! Tyger! burning bright
In the forests of the night,
What immortal hand or eye
Dare frame thy fearful symmetry?

AT THE MUSEUM

MUSEUM

On the morning of the Käthe Kollwitz exhibit, a young
man and woman come into the museum restaurant. She
is carrying a baby; he carries the air-freight edition of
the Sunday *New York Times*. She sits in a high-backed
wicker chair, cradling the infant in her arms. He fills a
tray with fresh fruit, rolls, and coffee in white cups and
brings it to the table. His hair is tousled, her eyes are
puffy. They look like they were thrown down into sleep
and then yanked out of it like divers coming up for air.
He holds the baby. She drinks coffee, scans the front
page, butters a roll and eats it in their little corner in
the sun. After a while, she holds the baby. He reads the
Book Review and eats some fruit. Then he holds the baby
while she finds the section of the paper she wants and
eats fruit and smokes. They've hardly exchanged a look.
Meanwhile, I have fallen in love with this equitable
arrangement, and with the baby who cooperates by
sleeping. All around them are faces Käthe Kollwitz
carved in wood of people with no talent or capacity for
suffering who are suffering the numbest kinds of pain:
hunger, helpless terror. But this young couple is read-
ing the Sunday paper in the sun, the baby is sleeping,
the green has begun to emerge from the rind of the
cantaloupe, and everything seems possible.

ROBERT HASS (1941–) 237

ON GOING BACK TO THE STREET
AFTER VIEWING AN ART SHOW

they talk down through
the centuries to us,
and this we need more and more,
the statues and paintings
in midnight age
as we go along
holding dead hands.

and we would say
rather than delude the knowing:
a damn good show,
but hardly enough for a horse to eat,
and out on the sunshine street where
eyes are dabbled in metazoan faces
i decide again
that in these centuries
they have done very well
considering the nature of their
brothers:
it's more than good
that some of them,
(closer really to the field-mouse than
falcon)
have been bold enough to try.

238 CHARLES BUKOWSKI (1920–94)

IN THE MUSEUM

a boy, at most
sixteen.

Besieged by the drums
and flags of youth,
brilliant gravity
and cornucopian stone

retreat.
The Discus Thrower
(reproduction)
stares as he crosses the lobby
and enters
the XIVth century.

I follow him as far
as the room with the blue Madonnas.

RITA DOVE (1952–)

STEALING *THE SCREAM*

It was hardly a high-tech operation, stealing *The Scream*.
That we know for certain, and what was left behind –
a store-bought ladder, a broken window,
and fifty-one seconds of videotape, abstract as an
 overture.

And the rest? We don't know. But we can envision
moonlight coming in through the broken window,
casting a bright shape over everything – the paintings,
the floor tiles, the velvet ropes: a single, sharp-edged
 pattern;

the figure's fixed hysteria rendered suddenly ironic
by the fact of something happening; houses
clapping a thousand shingle hands to shocked cheeks
along the road from Oslo to Asgardstrand;

the guards rushing in – too late! – greeted only
by the gap-toothed smirk of the museum walls;
and dangling from the picture wire like a baited hook,
a postcard: "Thanks for the poor security."

The policemen, lost as tourists, stand whispering
in the galleries: "... but what does it all mean?"
Someone has the answers, someone who, grasping
 the frame,
saw his sun-red face reflected in that familiar boiling sky.

IN A MUSEUM

I

Here's the mould of a musical bird long passed
 from light,
Which over the earth before man came was winging;
There's a contralto voice I heard last night,
That lodges in me still with its sweet singing.

II

Such a dream is Time that the coo of this ancient bird
Has perished not, but is blent, or will be blending
Mid visionless wilds of space with the voice that
 I heard,
In the full-fugued song of the universe unending.

THOMAS HARDY (1840–1928)

MUSEUM PIECE

The good gray guardians of art
Patrol the halls on spongy shoes,
Impartially protective, though
Perhaps suspicious of Toulouse.

Here dozes one against the wall,
Disposed upon a funeral chair.
A Degas dancer pirouettes
Upon the parting of his hair.

See how she spins! The grace is there,
But strain as well is plain to see.
Degas loved the two together:
Beauty joined to energy.

Edgar Degas purchased once
A fine El Greco, which he kept
Against the wall beside his bed
To hang his pants on while he slept.

THE MUSEUM OF FINE ARTS
IN BUDAPEST

How did you find yourself here,
poor mummy of an Egyptian priestess,
exposed to alien stares?
Now it is here you have your afterlife.
I myself am a part of it for a moment,
while I'm looking at you.

So far there is no other.
No one knows
if there will be.

RYSZARD KRYNICKI (1943–)
TRANS. ALISSA VALLES

METROPOLITAN MUSEUM

I came in from the roar
Of city streets
To look upon a Grecian urn.

I thought of Keats –
To mind came verses
Filled with lovers' sweets.

Out of ages past there fell
Into my hands the petals
Of an asphodel.

ACKNOWLEDGMENTS

Thanks are due to the following copyright holders for permission to reprint:

ALBERTI, RAFAEL: "Giotto" and excerpt from "Velázquez" from *To Painting*. Translated by Carolyn L. Tipton. Hydra Books/Northwestern University Press, Evanston, 1999. ASHBERY, JOHN: *Girls on the Run* (excerpt) by John Ashbery. Copyright © 1999 by John Ashbery. Reprinted by permission of Georges Borchardt, Inc., on behalf of the author. *Girls on the Run* [25 lines] by John Ashbery, from *Girls on the Run* (1999). Reprinted by permission of Carcanet Press Limited. AUDEN, W. H.: "Musée des Beaux Arts" copyright 1940 and renewed 1968 by W. H. Auden, from *Collected Poems of W. H. Auden* by W. H. Auden. Used by permission of Random House, Inc. "Musée des Beaux Arts" copyright © 1940 by W. H. Auden, renewed. Reprinted by permission of Curtis Brown, Ltd. BANG, MARY JO: "Machine Dance" from *The Eye Like a Strange Balloon*, copyright © 2004 by Mary Jo Bang. Used by permission of Grove/Atlantic, Inc. BAUDELAIRE, CHARLES: "On Delacroix's 'Tasso in Prison'" taken from *Les Fleurs du Mal* (tr. Richard Howard) (David R. Godine). BOLAND, EAVAN: "On the Gift of *The Birds of America* by John James Audubon". "The Carousel in the Park". Copyright © 1990 by Eavan Boland, from *New Collected Poems* by Eavan Boland. Used by permission of the author and W. W. Norton & Company, Inc. "On the Gift of *The Birds of America* by John James Audubon" and "The Carousel in the Park" from *New Collected Poems*. Reprinted by permission of Carcanet Press Limited. BROCK-BROIDO, LUCIE: "Lady with an Ermine" from *Trouble in Mind*:

edited by George J. Firmage. Used by permission of Liveright Publishing Corporation. DANIELS, KATE: "War Photograph" from *Niobe Poems* by Kate Daniels, © 1988. Reprinted by permission of the University of Pittsburgh Press. DAWES, KWAME: "Body Mask" taken from *Bruised Totems*, University of Wisconsin Libraries/Parallel Press, 2004. Copyright © 2004 by Kwame Dawes. Reprinted with permission from the poet. DOTY, MARK: "To Caravaggio" from *School of the Arts* by Mark Doty, published by Jonathan Cape. Reprinted by permission of The Random House Group Limited and the poet. "To Caravaggio" [19 lines] from *School of the Arts: Poems* by Mark Doty. Copyright © 2005 by Mark Doty. Reprinted by permission of HarperCollins Publishers. DOVE, RITA: "In the Museum" from *Grace Notes* by Rita Dove. Copyright © 1989 by Rita Dove. Used by permission of the author and W. W. Norton & Company, Inc. FERLINGHETTI, LAWRENCE: "Don't let that horse . . . (#14)" and "In Goya's greatest scenes we seem to see (#1)" by Lawrence Ferlinghetti, from *A Coney Island of the Mind*, copyright © 1958 by Lawrence Ferlinghetti. Reprinted by permission of New Directions Publishing Corp. FERRY, DAVID: *Strangers* (1983), "Plate 134. By Thomas Eakins. A Cowboy in the West", pp. 45 to 45. Reprinted with permission from University of Chicago Press. FINKEL, DONALD: "The Great Wave: Hokusai" taken from *Not So the Chairs: Selected and New Poems*, Mid-List Press, 2003. Reprinted by permission of Tom Finkel, Literary Executor, The Estate of Donald Finkel. FRAGOS, EMILY: "Art Brut" and "Figure with Hat" from *Hostage*, Sheep Meadow Press, 2011. Reprinted with permission from the poet. GINSBERG, ALLEN: "Cézanne's Ports" [12 lines] from *Collected Poems 1947–1980* by Allen Ginsberg. Copyright © 1984 by Allen Ginsberg. Reprinted

247

251